PRAISE FOR

Beautiful, Gruesome, and True

"Kaelen Wilson-Goldie writes with depth, nuance, and empathy about three artists who have dedicated their lives to grappling with violence, conflict, and war. She shows that it's both possible and essential to produce politically engaged art that truly matters, without fear or compromise. This book is an important contribution to contemporary debates over journalism, misinformation, and the nature of truth."

Beautiful, Gruesome, and True
Artists at Work in the Face of War

COLUMBIA GLOBAL REPORTS
NEW YORK

Beautiful, Gruesome, and True
Artists at Work in the Face of War

Kaelen Wilson-Goldie

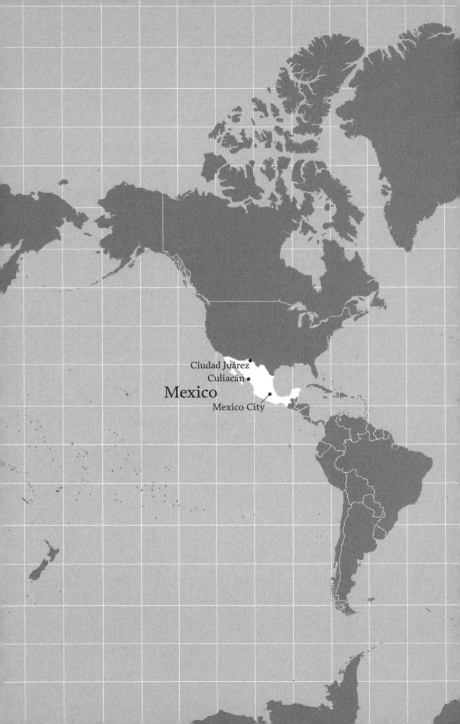

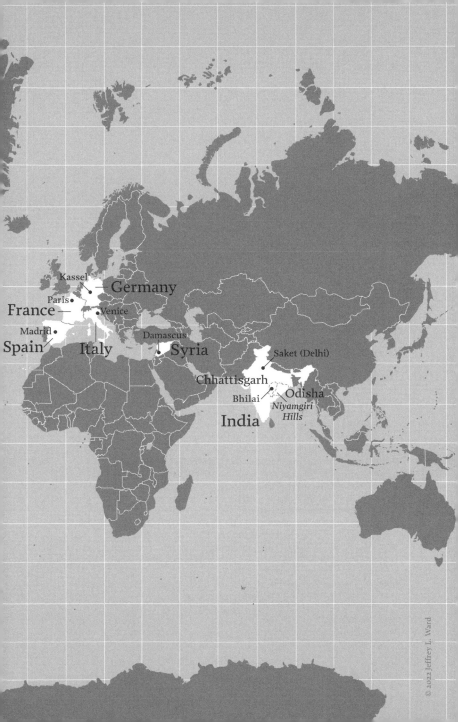

*Published with support from
the Andrew W. Mellon Foundation*

Beautiful, Gruesome, and True
Artists at Work in the Face of War
Copyright © 2022 by Kaelen Wilson-Goldie

Published by Columbia Global Reports
91 Claremont Avenue, Suite 515
New York, NY 10027
globalreports.columbia.edu
facebook.com/columbiaglobalreports
@columbiaGR

Library of Congress Cataloging-in-Publication Data

Names: Wilson-Goldie, Kaelen, author.
Title: Beautiful, gruesome, and true : artists at work in the face of war /
 Kaelen Wilson-Goldie.
Description: New York, NY : Columbia Global Reports, [2022] | Includes
 bibliographical references.
Identifiers: LCCN 2022014395 (print) | LCCN 2022014396 (ebook) |
 ISBN 9781735913728 (paperback) | ISBN 9781735913735 (ebook)
Subjects: LCSH: War in art. | Art and social conflict. | Kanwar, Amar,
 1964---Criticism and interpretation. | Margolles, Teresa,
 1963---Criticism and interpretation. | Abounaddara (Artist collective)
Classification: LCC NX650.W3 W55 2022 (print) | LCC NX650.W3 (ebook) |
 DDC 704.9/4935502--dc23/eng/20220512
LC record available at https://lccn.loc.gov/2022014395
LC ebook record available at https://lccn.loc.gov/2022014396

ISBN: 978-1-7359137-3-5 (ebook)
ISBN: 978-1-7359137-2-8 (paperback)

Book design by Strick&Williams
Map design by Jeffrey L. Ward
Author photograph by Ibrahim Saidi

Printed in the United States of America

For Amal Kenawy (1974–2012)
and Leila Alaoui (1982–2016)

History is usually the sum of instances and expressions of violence. There's also the history of ideas, the history of art, there are other histories. Since a very young age I've been preoccupied by conflict and social injustice. My position is very simple. There are many different ways of understanding the world that are connected. On the front lines, there are journalists. With a little more time, there are historians. There's also writers, musicians, artists who have other tools, other methods. We are complementary with anthropologists and sociologists and the people who talk at the counter when they are drinking coffee in the morning and cognac in the evening. We are all in our place trying to figure out what the fuck is going on.

ÉRIC BAUDELAIRE

CONTENTS

Preface

This book tells the stories of three artists who for various and intriguing reasons have been working in the face of war for a decade or more. In response to periods of extreme political violence, these artists have created bodies of work in film, photography, and multimedia installation. Their works have been shown in museums, exhibitions, and festivals all over the world, earning prestigious awards and critical acclaim while at the same time challenging ideas about what contemporary art can be and raising questions about how artists engage with their subjects, institutions, and audiences. All of this has implications at a time when images of war, atrocity, and disaster are everywhere and easily accessible. Why are some of the most interesting artists of our time drawn to such difficult subjects, and how do they manage to cut through the abundance of tragic material and our desensitization to violence?

In rural southeast India, Amar Kanwar has been listening to stories, recording old songs, collecting seed samples, and

working with local media activists to try and make sense of
the violence that has ripped through tribal lands in the drive
to extract precious metals from mountains deemed sacred to
their inhabitants for thousands of years. In the Mexican border
town of Ciudad Juárez, Teresa Margolles has met the mothers of
missing women, befriended a clique of endangered transgender
sex workers, gathered the shattered glass of drive-by shoot-
ings, and soaked up the blood of cartel executions, translating
these encounters into objects arranged in somber exhibitions.
In Syria, the anonymous members of the filmmaking collec-
tive known as Abounaddara have generated more than four hun-
dred extremely short, rigorously precise films, released one at a
time, every Friday, for a period of seven years. The films remain
openly available online as documents of a once-promising revo-
lution that morphed into civil war.

Kanwar, Margolles, and the few known founders of Aboun-
addara were all born in the 1960s, and belong to more or less
the same generation. But they do not represent a group or a
school or a movement within the field of contemporary art.
All of them are looking at situations of war, conflict, and vio-
lence and making works that are contemplative, orderly, and
contained. But it cannot be said that they share an aesthetic.
One would never mistake a film by Kanwar for a video by Mar-
golles or Abounaddara. They have each developed a sensibility
in their work that is distinct and dramatically different from
one another. And on a personal level, they are not friends or
colleagues, not even in the broadest sense. They have shown
in some of the same exhibitions and won a number of the same
prizes. But they are not close. They occupy places in the art

world that are difficult to pin down. None of them are particularly comfortable being associated with the art world in the first place.

What binds these artists together are the ways in which they work and the conditions upon which they insist. All of them are driven by a sense of greater purpose. Stubborn and single-minded, they have stuck themselves in specific places and committed their time to people who do not necessarily want or need their charity. There, in those contexts where death and dispossession and the loss of dignity are most apparent, they have found the tools, methods, and languages to make work that is then disseminated around the world under the rubric of contemporary art. Because these artists came into the art world from other disciplines, the question of why—why in the face of unconscionable violence making a work of art would seem like an adequate response—is one that runs throughout this book. Another question is to what effect. An artwork might have something different or more enduring to say about a given conflict when compared to journalism, activism, or human rights advocacy. But none of them have any real chance of bringing about the kind of resolution—such as an end to the war in Syria, the retirement of drug cartels in Mexico, or the restoration of tribal lands in India—that has eluded generations of diplomats, political leaders, and experts.

What, then, do these artworks do? With tremendous sensitively and unexpected power, Kanwar, Margolles, and Abounaddara show what the wars of our time have done to us as people who may be indifferent or apathetic to the complexities of long-simmering conflicts fueled by histories of colonialism—which implicates just about everyone. Given the materials they consist

of, the relationships they involve, and the forms of collaboration they demand, these artworks may have the greatest impact on the places where they are presented—that is, in the art world itself, especially at a moment of intensifying debates over how institutions behave and who brokers power. But in many ways, the work these artists do is barely connected to the art world, and fixing it has never been their intention.

Generalizations about the art world are easy to make but hard to verify. According to Art Basel and the Swiss banking giant UBS, the global art market is worth a yearly average of just over $60 billion, roughly equal to the annual GDP of a decently sized country—Croatia, for example, or Tanzania, or Uruguay. More than 80 percent of sales activity occurs in the United States, the United Kingdom, and Greater China. Galleries, dealers, and auction houses all took a huge hit from the COVID-19 pandemic, but there is still plenty of money sloshing around, much of it dirty or at least dubious. The market remains almost totally unregulated: suspicions of money laundering are real, and the drive to convert works of art into currency, to reduce them to quantifiable investments or an asset class, has been going on for years.

Beyond the bare bones of sales activity and financial transactions, the art world, such as it exists, runs on events. There are international art fairs for every day of the year, and nearly as many biennials. Before the start of the pandemic—and to a lesser extent since—people of means travel all over the world for art, so the art world gives the impression of being an arena for the filthy rich. Is it true? Maybe. Wealthy collectors, their bankers and advisors, their friends on museum boards and among business leaders, and others well compensated for their

18 ancillary services do account for a good number of the most vis-
ible people milling around art-world events.

But spend any time with artists, curators, critics, lower-
level museum staff, or the small army of culture workers all
over the world, and you may be forgiven for concluding that
the art world is in fact a leftist fantasia, home to all manner of
misfits and eccentrics. It is a place where theorists and activ-
ists are willing to throw down everything to try and unionize a
museum staff, boycott an institution's hiring choices, or protest
the sources of profit for particular board members. The curator
Cuauhtémoc Medina, from Mexico City, has described contem-
porary art as "the last refuge of political and intellectual rad-
icalism" and "the sanctuary of repressed experimentation." In
many places where political participation is limited or opposi-
tion is suppressed, the spaces where art is shown have become
real proxies for political discourse.

That may explain, in part, why people committed to specific
conflicts end up making contemporary art. But it also points
to obvious tensions. On one side of the art world are patrons,
collectors, museum directors, board members, and others with
financial stakes. On the other side are producers, artists, cura-
tors, writers, and others working for low pay who would like to
enact a certain kind of politics. Those tensions have only grown
more pronounced since the beginning of the pandemic and
the worldwide protests following the murder of George Floyd,
exposing massive inequalities and accelerating debates about
everything from toxic philanthropy to the ways in which sys-
temic racism has defined the foundations and practices of the
world's major arts institutions.

Artists, like students, have always been protesting some-
thing. But campaigns that once seemed fringe or fanciful have
recently made substantial gains. Nan Goldin's PAIN project,
attacking the pharmaceutical family responsible for driving up
opioid addiction, effectively stripped the Sackler name from
several prominent museums in the US and Europe. An artists'
boycott of the Whitney Biennial forced the resignation of board
member Warren Kanders over his ties to manufacturing tear
gas. A major contemporary art center in Rotterdam dropped
its colonial-era name—and adopted a new one honoring a
working-class hero—after three years of intense public work-
shops and community consultations. France pledged to return
a number of objects in its museums, looted in colonial times,
to Benin and Senegal. Germany announced that it was sending
several of the Benin bronzes back to Nigeria. Stolen artworks
that turned up in the US were repatriated to Egypt, Lebanon,
and Iraq.

Kanwar, Margolles, and Abounaddara have kept their dis-
tance from some of the more insular of these art world debates.
But they have been involved in campaigns, boycotts, and peti-
tions where their positions as artists have given them the
leverage to make demands. And they've each had to negotiate
complex institutional politics where their ethics were at odds
with someone else's. They've also been questioned, sometimes
aggressively, by fans of their work about where they stand in
relation to those causes.

Because Kanwar, Margolles, and Abounaddara are con-
stantly negotiating on either side of their work—on one side,
with institutions, to have their art shown under conditions

20 they can live with, and on the other side, with collaborators and the subjects most affected by the violence around them, to get their work made—they have created a model for how to get hard things done, an example of how to work better collectively. None fit the mold of the heroic artist holed up alone in his or her studio.

Few artists today would be naïve enough to admit wanting to change the world through their work, to bring an end to intractable conflicts, or to lessen the incredible amount of violence we are exposed to every day. Many might secretly wish it. The three artists who are the subjects of this book have translated a gruesome series of wars into powerful works of art. They have pointed out several different ways to have difficult conversations about ugly truths, unsettled histories, and unforgivable courses of action. And they have offered examples of working together, using art as an occasion for disruption and confrontation as well as a space of reflection and further thought. Short of actually changing the world, that might just be enough to make a difference.

Introduction

Throughout the summer and into the fall of 2019, a haunting artwork by Mexican artist Teresa Margolles stood in a darkened corner of an old warehouse in the Italian port city of Venice. The piece consisted of three large glass panels, each fitted into a freestanding metal frame, placed side by side at a bend in the segmented path through the Corderie, a former rope-making facility that runs, corridor-like, for nearly 350 yards, through the ancient brick columns and fresh plywood dividers of the Arsenale, a vast complex of decommissioned armories and shipyards in the Venetian neighborhood of Castello.

The glass panels in Margolles's installation, titled *La búsqueda* (The Search), 2014, were dirty, scratched in stray graffiti, and covered at eye level with wheat-pasted flyers that had been torn by time, weather, and the hands of passersby. The posters announced the names of one or a half-dozen missing women, with accompanying pictures ranging from unsmiling ID photos to joyous graduation portraits and the hopeful headshots of young professionals at the starts of their careers. Listed

22 beneath the images were the identifying details: ages, heights, specifics of appearance, dates of disappearance, places lived in or vanished from. Across the three panels, the ages of the missing women were frightful. Few of them were older than nineteen. Several were as young as thirteen. Many of them had been gone for a decade. All of the posters implored: "*Ayúdanos . . . Ayúdanos . . . Ayúdanos a localizarla*" (Help us . . . Help us . . . Help us locate her).

Margolles had found the glass panels five years earlier in Ciudad Juárez, a city plagued by drugs, crime, and the struggles of low-wage labor on the Mexican side of the border with the United States. For decades, the gruesome violence of competing drug cartels had overwhelmed Juárez. Then, starting in the early 1990s, there was a sudden and dramatic uptick in the number of women being kidnapped, tortured, and murdered in the city. More than three thousand people were murdered in Juárez in the year 2010 alone, out of a population of just 1.3 million. But even as the rates of other crimes eventually began to level off, the killing of women, most but not all of them young and poor, remained high. Hundreds of those murders were left unsolved. The crime wave continued, and beyond the battered social circles of the city itself the femicides were largely forgotten.

Equally sensitive to current events, political circumstances, and the more rebellious chapters of art history, *La búsqueda* evoked the work of Marcel Duchamp in two key ways, not only by repositioning a set of common objects as rarefied fine art, as Duchamp had famously done in works such as *Bicycle Wheel*, 1915 (a bicycle wheel turned upside down on a stool), and *Fountain*, 1917 (a urinal signed with the name R. Mutt), but also in emulating the sculptural form and spatial presence of the two

freestanding glass panels in Duchamp's *The Bride Stripped Bare by Her Bachelors, Even*, 1915–1923, also known as *The Large Glass*. Margolles had taken her glass panels from a bus stop in the historic city center of Juárez, and turned them into contemporary art like unsuspecting urban readymades wrestled into the cool, serial language of minimalist sculpture.

The installation also embodied the more activist, interventionist spirit of a large subset within the field of contemporary art, roughly defined as politically engaged or driven by a demand for social justice. As documents, the faded posters, whether vandalized or smudged by greasy fingers or fixed to the glass as far back as 2009, called attention to the extreme pain of Juárez, to the fates of women who disappeared, to the struggle of mothers still searching for their daughters, and to the city's loneliness and desolation, like night falling on a once lively place, now emptied of everything but dread.

The real power of Margolles's piece did not come from the flyers alone. It came from the fact that the glass panels were rattling slightly in their frames. The most important part of the piece was in fact a hidden audio track, which transformed sound recordings the artist had made of freight trains rumbling through Juárez into a frequency so low that it shook the glass panels at periodic intervals when they were installed in the exhibition space. The dim but jarring sounds of the shaking panels coupled with the stories of the missing women made it feel as though the piece was being rocked by angry ghosts.

La búsqueda had been shown in other museums and arts institutions, before the installation was transported to Northern Italy for the fifty-eighth edition of the Venice Biennale, where it was shown as part of curator Ralph Rugoff's now

seemingly prophetic exhibition, whose title, "May You Live in Interesting Times," came from an apocryphal Chinese curse, attributed to a British diplomat, who invented its provenance and passed it along to a member of parliament, who in turn used the expression in a 1936 speech warning about the very real dangers of Hitler and the rise of fascism in Europe. "We move from one crisis to another," the diplomat said. "We suffer one disturbance and shock after another. . . . There is no doubt that the curse has fallen on us." The saying never actually existed in Chinese philosophy, folklore, or proverbs, but it has been repeated down the ages by everyone from Albert Camus and Arthur C. Clark to Robert F. Kennedy and Hillary Clinton. "For an exhibition that [considered] how art functions in an era of lies, it struck me as an apt title," Rugoff wrote in a curatorial statement. An American based in London, where he directs the Hayward Gallery, a public institution down the road from Tate Modern, Rugoff turned the phrase into a capacious curatorial framework, generous enough to include the complexity and nuance of nearly eighty different artists responding to a litany of urgent, timely issues in an age of fake news and alternative facts.

"The idea was that interesting times were times of change, potentially times of revolution, disaster, war, famine," Rugoff explained in an interview with the *Los Angeles Review of Books*. "So, you really wanted to live in boring, stable, prosperous times." In addition to *La búsqueda*, Rugoff included in the exhibition Margolles's *Muro Ciudad Juárez* (Juárez City Wall), 2010, a barrier of concrete blocks riddled with bullet holes and topped with barbed wire, which the artist had taken from the yard of a public school where four young people were killed in a run-in with organized crime.

Margolles won a special mention from the jury of the
Fifty-eighth Venice Biennale. Many people remembered her
work for the Mexican national pavilion of the Fifty-third Venice
Biennale, ten years earlier, which involved mopping the floor of
a dilapidated palazzo with the blood of the victims of Mexico's
violence. It was called "one of the most memorable and fright-
ening works ever shown there."

Margolles is certainly exceptional, but she belongs to a
larger group of like-minded contemporary artists who approach
their work as an inherently political practice. They delve into
complicated, difficult, and ambitious subjects, such as life,
death, love, pain, dignity, and injustice. But more than that, they
transform the materials they find into unexpected forms that
are most notable for being contemplative, thoughtful, orderly,
even redemptive. From the chaos of wars or sustained periods of
seemingly senseless violence come details, anecdotes, digres-
sions, traces, examples, and evidence that are then translated
into a moving array of objects, an exquisite grid of images, a
beautifully composed narrative, or a highly ritualized perfor-
mance. Although they don't constitute a school or a movement,
artists like Margolles represent a considerable amount of the
work being made in the name of contemporary art today.

That may come as a surprise to anyone holding onto the idea
that the art of our time should be pretty, pleasant, uplifting, or
that the more general purpose of culture is to delight and enter-
tain. But artists have always been working in close proximity or
direct response to political violence. Even the most traditional
of art histories trace a crucial if brutal lineage. The most obvious
example is Picasso's *Guernica*, 1937, an enormous mural cap-
turing, in discombobulated fragments, broken glass, and shades

of black and white, the incendiary bombing of a tiny Basque town by German and Italian forces. Maybe the best known anti-war work in history, it marks the advent of total war, blitz-krieg tactics, and the targeting of civilians in the mid-twentieth century. From there, one can reach back in time to the three versions of Édouard Manet's *The Execution of the Emperor Maximillian*, 1867, 1867–68, and 1869, depicting a firing squad poised to kill the young Austrian archduke who was installed by Napoleon III as the ruler of a French monarchy in Mexico. The series culminates, in the last painting, with the sudden appearance of a crowd of voyeurs who foretell the ways in which atrocities will be transformed into spectacle. Moving further back, there is Goya, the eighteenth-century history paintings of Géricault and Delacroix and David, the blood and gore of Caravaggio, and the intense Renaissance battle scenes of Paolo Uccello, Leonardo da Vinci, and more. Go as far back as the epics of ancient Greece, India, and Mesopotamia, and you'll find that even those early poets dwelled at length on descriptions of war.

An obsession with violence doesn't necessarily run counter to the purpose of art but rather supports its possible role in sublimating passions—redirecting, say, the death drive toward more productive ends. As Susan Sontag argues in her landmark essay "Against Interpretation," paraphrasing Aristotle: "Art is useful . . . medicinally useful in that it arouses and purges dangerous emotions." Some of the best and most enduring works of art about willful, man-made crises are shaded with humility. They show us that, as a species, we are capable of many wondrous things, including the transcendent power of art. But at the same time, they remind us of our baser instincts, of our propensity to do great damage to each other, the planet, and ourselves.

That is not to say that artists like Margolles are making explicitly political art, a dutiful category of earnest, often joyless, and mostly terrible work that is usually intended to serve as an instrument or tool in achieving a specific goal. "I don't think anyone in this exhibition is making political art," Rugoff said of the artists in "May You Live in Interesting Times." "I think some of them are making art politically. They're thinking politically. But to me political art means art that's trying to drive home one message or is trying to make one point about one issue." The artists in Rugoff's show weren't doing that. They were raising questions, making connections among disparate things, framing events of the day in new or different ways.

In that respect, such artists sometimes do the work of journalists, novelists, sociologists, and anthropologists. One of the major themes running through contemporary art since the 1990s involves archival investigations into past moments of political upheaval and potential, for example, in relation to independence movements or the process of decolonization. Or those investigations delve into periods of violence that have been overlooked or covered up. Exceptional works of contemporary art sometimes surpass investigative journalism, documentary films, or the advocacy of human rights campaigns because they are able to take their audiences by surprise. They can convey the sensation of living through a crime wave, the corporate pillaging on indigenous lands, or the collapse of a revolutionary movement in the barbaric onslaught of civil war to a crowd of people who may have been hoping for some pretty pictures but had their minds blown by a video installation instead.

It is somewhat disorienting to look back now on "May You Live in Interesting Times." Rugoff's edition of the Venice

28 Biennale was the last to happen before the start of the global COVID-19 pandemic. The next edition, organized by Italian curator Cecilia Alemani and inspired by artist Leonora Carrington's surrealist children's book *The Milk of Dreams,* was delayed by a year. Such interruptions in the schedule are rare. In retrospect, "May You Live in Interesting Times" sounds like "Be Careful What You Wish For." The conflicts and crises of just a few years ago have multiplied in number and gravity. The institutions, circulatory systems, and survival modes of contemporary art have themselves come under enormous strain.

For all its promise, Rugoff's exhibition didn't always hold together or add up to the sum of its parts. One could argue that Rugoff padded the exhibition with more frivolous modes of art-making in order to make it palatable to mainstream tastes. Still, at its core, the show offered a remarkable concentration of artists thinking politically today. There have been other shows like it, and there are more artists working in the same vein as Margolles. Few of them are as good or as challenging as she is. But the ones who are have much to tell us about how contemporary art has changed and what it could be in the future. This book focuses on three of them.

The story of the work of Amar Kanwar begins, in part one, with the assassination of a charismatic labor leader in the central Indian state of Chhattisgarh, an event the artist describes as both the gate-crashing arrival of twentieth-century globalization and a pivotal moment in his political life.

Part two takes up the story of Teresa Margolles's work, first by revisiting the explosive exhibition "What Else Could We Talk About?" staged in 2009, and then moving backward and

forward in time to consider her early work with the collective
SEMEFO, and her more recent work on a group of transgender
women and sex workers in Ciudad Juárez.

The work of Abounaddara rounds out part three. Ini-
tially composed of a small group of filmmakers working anon-
ymously in Syria, the group came to widespread attention in
the years following the start of the revolution, which began in
2011 with protests scattered around the country, inspired by the
Arab Spring. Just as the uprising was organized around Friday
demonstrations, Abounaddara posted one short film to Face-
book, Twitter, and Vimeo at the end of every week, in solidarity
with the protesters.

The idea for this book came together at a time when I had
been following the work of each of these three artists, sepa-
rately, for a number of years. I began to wonder what it would
mean to look at their projects side by side. Amar Kanwar, Teresa
Margolles, and Abounaddara create dramatically different art.
What linked them together in my mind, and set them apart
from their peers, was the consistency and coherence of what
each of them was doing in the face of horrific violence and long-
standing conflict, the awful if typical forever wars of our age. As
I began to think about their work together, the importance of
collaboration, of trying out different modes of working collec-
tively, quickly emerged as a question I wanted to pursue. It was a
common element that distinguished their work, and it seemed
to have been born of the time and seriousness they had each
devoted to their subjects.

That said, this book is not a work of critical theory or art his-
tory. Although I dwell at length on certain institutions as nodes
in the circulatory systems of contemporary art, and despite my

30 abiding interest in how those institutions are tied to longer,
older histories of war, violence, and political conflict, this book
is not an exposé of all the contradictions, compromises, and
complicities inherent to the art world today. This book is lastly
not a joint biography of these three artists. Some people love to
place their own stories, backgrounds, and identities at the heart
of their work. Amar Kanwar, Teresa Margolles, and Aboun-
addara decidedly do not. The stories I tell are the stories of the
work, not the stories of the makers, and those stories are them-
selves a work of journalism and criticism, first and foremost.

The title *Beautiful, Gruesome, and True* is meant to describe
the many artworks that are discussed at length but never shown
in a book that is being published without a single image repro-
duced on its cover or in its pages. My hope is that some readers
will already know these artworks and other readers will enjoy
the freedom to imagine them. In any case, anyone with a decent
internet connection can find a wealth of images online showing
many stills from Kanwar's films and multiple views of Mar-
golles's installations; Abounaddara's archive of four hundred–
plus films, made from 2010 through 2017, is still parked on
Vimeo, free for all to see.

Kanwar, Margolles, and Abounaddara belong to a long tradi-
tion of artists dealing with political violence in their work. But
the recitation of epic poems that told of distant wars operated in
a very different conception of time from our own. Renaissance
battle scenes that were meant to cower viewers with their grisly
details assumed an audience that was almost always on the win-
ning side. Kanwar, Margolles, and Abounaddara have more in
common with artists closer to their time, a generation before,
a generation after, contending with how ubiquitous images of

atrocity have become, whether in magazines, on television, or online. What sets Kanwar, Margolles, and Abounaddara apart is how long each has spent at work in a single place, in response to a specific conflict, finding modes of enduring collectivity and lasting collaboration—and in doing so, slowing the pace of internet time by demanding more deliberate and methodical ways of thinking.

"Artists are seldom brave, nor need they be," the art historian T. J. Clark said about Picasso and others in the time of *Guernica*. Kanwar, Margolles, and Abounaddara would never describe themselves as brave, though their work is undoubtedly fearless. This book about them is dedicated to two younger artists like them, who came along in the generation after and should have been just now hitting their stride. Amal Kenawy and Leila Alaoui worked in similar ways. They put themselves in volatile situations, stuck with it, created an incredible record of work, and paid far too heavy a price for their bravery. Kenawy, who made wildly surrealist videos and provocative street performances that chiseled into deeply held hatreds of women in Egypt, earning her run-ins with the police and prison, died of illness in 2012 at the age of thirty-seven. Leila Alaoui, who made films and photographs about the effects of migration on identity and community in Morocco, was killed in 2016 in a terrorist attack in Burkina Faso, caught in the wrong place at the wrong time, at the age of thirty-three. I wrote this book for them, for the risks they took, and for the work they made in a world that still has a lot to learn from artists like them.

Amar Kanwar

Part One

Paradise Lost, Chhattisgarh

Shankar Guha Niyogi knew his life was in danger. A charis-
matic trade unionist, Niyogi had refused to go into hiding, but
he agreed to move and set up a new home and office in Bhilai,
an industrial city in the mineral-rich region of Chhattisgarh.
Early in the morning on September 28, 1991, two men on a red
Suzuki motorcycle pulled up alongside Niyogi's building while
he was sleeping under mosquito netting in a room on the ground
floor. One of the men propped open a window, leaned in, and
shot Niyogi six times. Then he fled with his companion on their
motorcycle.

Niyogi was rushed to a nearby hospital, but every bullet had
pierced the back of his head or his neck. He was killed at the age
of forty-eight, leaving behind a wife and three children. Within
hours, hundreds of distraught people turned up at the morgue
in Bhilai. The next day, Niyogi's body was returned to his family
in the mining town of Dalli-Rajhara for cremation. More than
one hundred thousand mourners, grief-stricken, outraged, and

34 stressed, poured in from across the Indian heartland. They came from factory towns and labor camps, slums and villages, farms and forests. The hills of the surrounding region were populated by millions of Adivasis, members of India's so-called "scheduled tribes," whose lives had been measurably improved by the decades-long work that Niyogi was doing in the region. The local press described him as "the uncrowned king of 10,000-odd workers in the Durg-Bhilai industrial belt." Indigenous leaders called him the Gandhi of Chhattisgarh. His death marked an end to one of the most hopeful chapters in the history of the Indian labor movement.

In the weeks and months prior to his assassination, Niyogi had been leading a strike among the workers of a major steel plant, part of a wider campaign for living wages, more permanent jobs, and the right to unionize. His ideas and methods had grown into a mass movement, which came to be known under the umbrella organization called the Chhattisgarh Mukti Morcha, or the Chhattisgarh Liberation Front.

What made the Chhattisgarh Mukti Morcha so captivating—and also, one imagines, so threatening to industrialists and the politicians in their pocket—was the fact that Niyogi established common ground among factory workers, farmers, peasants, the rural poor, and tribal communities who were ancestral to the area and had, for centuries, considered the mountains of central India not just sacred but the physical embodiments of their living gods. If Niyogi led a strike in a steel plant that succeeded, then the steelworkers union would contribute to a campaign for the rights of indigenous tribes. If that campaign worked, then the tribes would throw their weight behind an agitation by local

farmers, creating a support structure across communal lines
that was both unprecedented and politically powerful.

Niyogi also did the one obvious and necessary thing that
almost no other labor initiative or civil rights group of that era
thought to do: he made women and their issues—including
childcare, maternity benefits, and protection from domestic
violence—central to the movement. The Chhattisgarh Mukti
Morcha went far beyond the basics of workers' rights to address
issues of health, education, and leisure time.

After Niyogi's death, his wife, Asha, herself a miner, publicly
accused nine prominent industrialists of ordering his assassi-
nation. Six years later, in 1997, five people, including three of the
industrialists, were convicted of conspiracy to commit murder
and sentenced to life in prison. The gunman, an assassin-for-hire
who was implicated in a smattering of local crimes, was given a
death sentence. It was the first time that factory owners in India
were found guilty of killing a labor activist. It was considered a
judicial triumph, a rare example of justice being served, and the
acknowledgment of a species of crime that was known to happen
but hard to prove, and even harder to pin on men of importance.
But then a higher court overturned the convictions in 1998. In
2005, the case went to the Indian Supreme Court, which acquitted
the industrialists and everyone with them of the crime. Only the
gunman—thought to have carried out the killing for a very small
sum of money—was jailed for life. The labor struggle in Chhat-
tisgarh soon entered a vortex of escalating violence among para-
military forces, corporate interests, and local insurgents.

The anthropologist Felix Padel, who has been studying
industrialization and the destruction of tribal life in the Bastar

36 region for years, describes the level and intensity of conflict in Chhattisgarh as possibly the worst that India has ever seen, comparable to Darfur fifteen years ago or Syria at the height of its civil war. Although it is rarely covered by the international media, "Chhattisgarh has been a war zone for more than a decade."

Niyogi received numerous death threats, and in fact had predicted his own death on a micro-cassette recording he made just a few weeks before his assassination. He refused to hire a bodyguard, despite friends and colleagues urging him to do so. Instead, through a senior leader, a woman who was active in the union (and remains so today), he invited a young filmmaker from Delhi to come to Chhattisgarh and document the work the movement was doing. Niyogi wanted someone he could trust. It's possible that he wanted evidence if his life ended in a crime. But mostly he wanted someone young with a camera and six to eight months of free time.

Amar Kanwar was twenty-seven years old and had plenty of free time. Kanwar had graduated from Delhi University's highly politicized department of history, and in the late 1980s, he enrolled in a master's program in mass communications at Jamia Millia Islamia, which he chose for no other reason than it had no exams. The program was India's youngest de facto film school at the time. Kanwar learned how to make documentaries despite having seen very few and professing no interest in them. In 1991, he was making small, educational films in Delhi for the equivalent of a hundred dollars apiece. "I made a film about standing in line," Kanwar told me when I visited him in the summer of 2018. "I made a film about refraction, about why the sky turns red at twilight. I made a film about pantomime." He tackled weightier

subjects, too, such as the relationship between HIV and prostitution, the leather industry, workmen's compensation, and migrant labor. Although he described his work from that time as clumsy, he was slowly building a reputation among filmmakers as someone who approached difficult topics with sensitivity. "I was doing my own thing," he explained, "making stupid films, with no money, broadcasting at the worst hour in the day—and I was working alone."

When Kanwar was invited to film Niyogi and the Chhattisgarh Mukti Morcha, he didn't have his own camera, and he didn't have the money to buy a plane ticket to Chhattisgarh. He eventually borrowed money for the flight and got his hands on a new portable camera, which a friend had surreptitiously lifted from the French embassy. But when Kanwar arrived in Chhattisgarh, it was too late. He landed on September 29, 1991, the day of Niyogi's funeral.

Sparks in Saket

Kanwar has lived almost all of his life in the same Delhi neighborhood, on the same S-curved street, that his family arrived to in 1976. He was twelve at the time and thought the residential blocks of Saket, deep in South Delhi, were pure wilderness, the end of the known world. Saket was primarily agricultural land back then, an expanse of fields and forests scattered with archeological ruins, including stones from the winding medieval walls that once fortified the very first city of Delhi. The area has filled in since the 1980s—the main attractions now are three large shopping malls with elaborate food courts—but it still allows Kanwar the time and space to work without distraction on projects that take years, even decades, to complete.

In the thirty years since he was a young filmmaker traveling to witness a utopian people's movement that was under threat in Chhattisgarh, Kanwar's work has shifted off of television, out of the documentary tradition, and into the more sinuous and rangy channels of contemporary art. In addition to his earliest short films, Kanwar has made thirty to forty titles since the

1990s, but the majority of his works are now screened in exhibition venues as part of larger, often more complicated, installations. He may be the only artist in history to be included four times, in four consecutive editions, of Documenta, the brainiest of all blockbuster art events, established as a mode of cultural redress in the aftermath of World War II and held every five years in the central German city of Kassel, as a weathervane for where contemporary art is going.

None of that makes Kanwar famous per se. He doesn't have a high public profile. He doesn't cycle through endless residencies and fellowships. He's probably the least likely of any artist with blue-chip representation to socialize in the frothier tiers of the art world. He doesn't have a studio in London, Berlin, or New York. He is known to be reclusive, low-profile, and reserved. He has traveled to virtually every corner of his own vast country, but he hates going abroad. To this day, Kanwar can stand in the same street where he grew up, point to the house where his older brother lives, turn, and point to the house where his father lives.

When this particular block in Saket was first built, it was assumed that most of the people moving in would want to hire staff of some kind—a maid, a nanny, a cleaner—but that few of them would plan to own a car. For every small street, only a handful of garages were constructed, each designed with the size of an Indian-made Ambassador in mind. Over time, the so-called servants' quarters were transformed into small apartments, which owners would rent out for additional income. The garages became small businesses, now occupied by tailors and launderers. For Kanwar, a series of those servants' quarters and garages eventually became his studio, until he reached a point when he needed (and was able) to rent whole apartments as

40 spaces to make and store his work. When I visited Kanwar in the summer of 2018, he had two such apartments up and running. One was his home, the other his studio. In the latter, there were shelves full of books but very little of the material, gear, or equipment one might expect from a contemporary artist who is both a maker and a collector of seemingly incidental things.

Kanwar was in a lull between works. The previous year, he had completed a major feature-length film, titled *Such a Morning*, for Documenta 14. *Such a Morning* depicts a mathematician who at the height of his career suddenly takes a few belongings and moves into an abandoned train carriage in the woods on the outskirts of his city. The reason? He is going blind. Kitting out his train carriage like a child's fort, the mathematician waits for darkness to fall, and then explores that darkness in full. As he begins to hallucinate, viewers are treated to an aesthetic feast. The mathematician sees streaks of light, diminutive explosions, and synaptic sparks like so many tiny fireworks. The film then shifts its attention to a woman seated in an armchair in the middle of a room with a rifle across her chest. As she sits there stoically, a team of young men begin to dismantle her house, stripping away possessions and building materials in a manner that is both delicate and systematic. Slowly the camera pulls back to reveal a mountainous landscape with signs of urbanization in the distance—the setting is a Naga tribal village in the northeastern state of Manipur. As the mathematician heads into the woods, the woman gets up from her chair and walks away, leaving the scene without her gun.

Critics have interpreted *Such a Morning* as a finely calibrated allegory of the search for safe haven amid rising political tensions in India today, where often-violent right-wing

Hindu nationalism is ascendant. But Kanwar has never made
any explicit connection between the film and the rise of Nar-
endra Modi as India's prime minister, or the dramatic con-
solidation of power among virulently Hindutva parties. He
describes it as "a modern parable about two people's quiet
engagement with truth."

Since Documenta 14, *Such a Morning* had five- and six-
month runs at the Ishara Art Foundation in Dubai and Toron-
to's Prefix Institute of Contemporary Art. The film inspired a
dedicated seminar at the New School's Vera List Center for Art
and Politics in New York and a yearlong program on solidarity
building and collective action by the Feminist Memory Project
and Nepal Picture Library in Kathmandu. It has been screening
somewhere in the world, almost without interruption, for years,
even well into the COVID-19 era.

Kanwar's parents crossed over from what became Pakistan to
what remained India as Punjabi refugees in 1947. His father's
family was forced to live in a camp, then a barracks, and then
were squeezed into the house of distant relatives, who swindled
them of their money. Kanwar was born in Delhi in 1964, after his
father became a naval officer, so the family moved around. He
spent much of his early childhood in southern India, growing
up in the lush, nearly tropical port cities of Kochi and Mumbai.
Kochi was famous for its open-air film clubs. With rented pro-
jectors and borrowed films, local cinephiles organized informal
outdoor screenings of popular commercial movies, the jewels
of world cinema, and art-house fare such as Satyajit Ray's *The
Apu Trilogy*. Kanwar caught his first glimpse of cinema in those
open-air screenings.

42 In the early 1970s, Kanwar's father landed a coveted position back in Delhi. The family stayed with relatives in a rough-and-tumble district of traders and merchants, so Kanwar had to learn how to deal with gangs of street-smart kids whose games devolved easily into violence, such as one child stabbing another for sport. "Life was always out on the street and it was rough," he said. After a few years, the family secured a home of their own, part of a newly built development in Saket.

Kanwar was a student at Delhi University in 1984, when Prime Minister Indira Gandhi was assassinated by her Sikh bodyguards. It was an act of revenge for her decision to order a military attack, known as Operation Blue Star, on a holy Sikh temple in Amritsar. Her death was followed by days of horrific retaliatory violence, of gangs roaming the streets, "killing, burning and looting at will," as reported by the BBC's Satish Jacob and Mark Tully. "India seemed to be going up in flames." Officially three thousand and unofficially eight thousand Sikhs were killed, and fifty thousand people were displaced from their homes. Kanwar's college had already been roiled in years of protest and violence. With the assassination and riots, his department shut down completely. Students and teachers joined relief efforts on the ground. "We were in a school not far from here," Kanwar recalled, gesturing out his windows, "full of devastated families who had lost everybody. They couldn't believe what had happened to them. They'd seen their husbands and fathers burned alive."

A few months later, an accident at a pesticide plant in the central city of Bhopal killed some fifteen thousand people and exposed more than six hundred thousand to toxic gas. It was one of the worst industrial disasters in history. In the aftermath,

Kanwar joined the demonstrations calling for accountability
and reforms. "Families were coming from Bhopal by overnight
train, arriving here in Delhi, a thousand families, two thousand
families, to protest."

In 1996, Kanwar made a documentary about water resources
in Rajasthan, called *Marubhumi*. After making the film, he fell
into despair. "All the offers of work I was getting, all around, had
this little twist inside them, which was quite conservative or
ugly," he said. "I ended up deciding to quit."

Around that time, a fellow filmmaker took a job as the com-
missioning editor of a new series funded by a group of interna-
tional foundations. Each of the six or seven films in the series
was meant to tackle a theme, such as governance, democracy, or
ecology. No one wanted to do the film on violence. Was Kanwar
interested? "It seemed like a namby-pamby subject," he recalled,
"because what can you say about violence except that it should
not happen? You would have to say some goody-goody things."
Nevertheless, he took the job and made a decision: if it was
going to be the last film he made, then at least it was going to be
a film he believed in.

A Season Outside (1997) was Kanwar's masterpiece. It unfolds
as a thirty-minute meditation on how to deal with the violence
of partition as it is perpetuated through memories, dreams,
reenactments, and more. The work begins on the border of India
and Pakistan, where day laborers in different-colored clothing
pass bundles back and forth, followed by a long sequence cap-
turing the highly theatrical ritual of Indian and Pakistani sol-
diers closing the border gates in the evening, drawing down and
folding up their flags. From there, the film travels to different
sites or zones, touching down on historical re-creations of the

44 Sikhs celebrating the moment they armed and politicized their religion; to observing two crows tormenting a small puppy; to a Tibetan refugee camp, where one small child shoves another in the street. Kanwar mixes in archival footage: one sequence shows Gandhi as he picks his way through a landscape with a walking stick and a swarm of followers; another sequence shows army soldiers torturing a prisoner. "I'm on the border of India and Pakistan," Kanwar says in the film's voice-over. "I have a compass which keeps spinning me into zones of conflict. It's a very peculiar feeling here, because that very line scattered my family across the subcontinent. Like seeds in the wind they flew, each carrying their own box of color."

When *A Season Outside* was done, the funders organized a tour to screen the film all over India. That tour overlapped exactly with the research phase of the late Nigerian curator Okwui Enwezor's edition of Documenta, which opened in Kassel in 2002. Documenta 11 is widely considered one of the most significant exhibitions of contemporary art's so-called global turn, which opened up a sometimes brittle, conservative, and canonical art world to a rush of truly cosmopolitan, post-colonial, non-Western leftist influences. Over the course of a short but brilliant career, Enwezor, who passed away in 2019 at the age of fifty-five, did arguably more than anyone to bring the exceptional, consequential work by artists from the so-called third world into meaningful and equal dialogue with that of their first-world peers. In the years leading up to his exhibition in Kassel, Enwezor organized an elaborate series of conferences, workshops, research projects, and public film programs on four continents to extend Documenta's reach beyond Europe.

Revolving around themes such as democracy, creolization, and
transitional justice, the events took place in Freetown, Johannesburg, Kinshasa, Lagos, on the Caribbean island of Saint Lucia, and in Delhi, where Enwezor saw *A Season Outside* for the first time.

But *A Season Outside* was already five years old, so Enwezor commissioned Kanwar to make another film. *A Night of Prophecy* (2002), which had its world premiere at Documenta 11, officially marked Kanwar's entrance into the art world, at its apex. A sequel to *A Season Outside* (and together forming a trilogy with 2003's *To Remember,* a silent film honoring Gandhi), *A Night of Prophecy* is a seventy-seven-minute tour de force piecing together various recitations of established and vernacular poetry—about violence, conflict, tragedy, pain—in eleven languages from across India. It includes a searing line from a 1970s poem by Prakash Jadhav called "Under Dadar Bridge," where a young Dalit man asks his mother whether he is Hindu or Muslim and she responds: "You are an abandoned spark of the world's lusty fires."

Over time, Kanwar's experience with political injustice and environmental degradation had coalesced into a theory: if acts of violence continue to occur, despite all the available evidence that should be used to stop them and achieve lasting justice, then perhaps it is how evidence is conceived, constituted, and understood that needs to change. Kanwar's proposition, present throughout his oeuvre but fully articulated in *A Season Outside* and *A Night of Prophecy,* is to consider poetry the most powerful form of evidence to convey the magnitude of what has happened, over forensics, eyewitness testimonies, or facts and figures. It was thanks to Enwezor and Documenta that Kanwar

46 could develop this theory and test it out in the literal and figurative spaces of contemporary art.

Many in the Indian art world initially objected to the work of a documentary filmmaker being elevated to the status of fine art in a showcase as prominent as Documenta. It would be fine for Kanwar's works to screen in a parallel film program but not in the main exhibition. *A Season Outside* and *A Night of Prophecy*, however, helped to redefine the kinds of work that counted as contemporary art, both within India and beyond.

Documenta is both emblematic and anachronistic in the global exhibition system to which it belongs. It is widely considered the most esoteric and cerebral event of its kind, if you consider it similar to the hundreds of other events of international contemporary art that are scheduled throughout a given year, usually on a biennial or triennial basis. And yet, the particularities of Documenta's history make it different. It was founded in 1955 for the explicit purpose of stitching Germany back into European cultural life, while at the same time allowing space for artists to address, directly or obliquely, the horrors of what had happened under Nazism.

Early editions of Documenta focused on restoring attention to modern art movements—cubism, expressionism, fauvism, futurism—that were dismissed in wartime Germany as degenerate. Later editions began delving into racism and the legacy of lynching in the United States, apartheid in South Africa, the AIDS crisis, the threat of nuclear disaster and the effects of the Cold War, Palestinian dispossession, the Lebanese civil war, the destruction of the Bamiyan buddhas in Afghanistan, and, eventually, the tangled history of nearby sites such as Breitnau, a former concentration camp located in a monastery just outside

of Kassel, and the seemingly contradictory role of Documen-
ta's host city in the lucrative and ongoing business of arms
manufacturing.

Since its founding, Documenta has grown in size and scope.
The demands to produce ever-more ambitious commissions
have slowly brought the pressures of the high-stakes inter-
national art market to bear. But compared to other such exhi-
bitions, Documenta maintains a decidedly non-commercial
stance. To a certain extent, it sets the agenda for the exhibitions
to be rolled out in major museum and gallery shows in the fol-
lowing years. As such, and also for the more practical reason
that there is very little else to do in Kassel (unlike, say, in Venice,
where every two years the opening of the Venice Biennale is
attended by glamorous events), Documenta remains particu-
larly well suited to artworks dealing with urgent issues of the
world. Perhaps for that reason, Kanwar's long films and immer-
sive installations, which demand a great deal from viewers and
do not offer easy answers to the difficult questions they pose,
have so often found a gracious home there.

Sovereign Forest, Odisha

When Kanwar arrived in Chhattisgarh on the day of Niyogi's funeral in 1991, a group of women factory workers were sitting on a traffic island, staring off into space. Like many of the people gathered there, they were stunned by the assassination. They turned to look at his camera and immediately burst into tears, mistaking Kanwar for Niyogi's younger brother. "I had never seen so many people," he said. "Imagine eighty thousand, ninety thousand people, workers in the middle of the road, constantly coming in from the surrounding rural areas." Many of them were wearing the red and green of the Chhattisgarh Mukti Morcha flag.

When Kanwar returned to Delhi, he turned his material into a thirty-seven-minute film titled *Lal Hara Lahrake*, named for the waving red and green flags. Over the next thirty years, he returned many times to Chhattisgarh, shooting footage there for *The Many Faces of Madness*, a documentary about the destruction of farmland and natural resources, and for a fifty-eight-minute film on resistance movements called *Freedom*. In an essay for the Indian art journal *Marg*, Kanwar described the Chhattisgarh

Mukti Morcha as "the most inspiring political mass movement I had even seen. Beautiful, powerful, vulnerable men and women involved in a unique process of creation and struggle." He wrote that he didn't have the vocabulary to tell the full story of what had happened there, and that much or indeed all of his work since then was about finding new or different ways of telling, even of seeing, events of such magnitude.

Niyogi's killing marked the arrival of twentieth-century globalization in India precisely because it destroyed the last line of resistance to it. Author Rana Dasgupta writes in *Capital: The Eruption of Delhi* that in India's post-liberalization era, the poor were the most adversely affected by globalization not by being left out of it but by being so totally sucked into it. Their living conditions deteriorated throughout the 1990s "not despite the boom in the Indian economy but because of it." One of the major components of that boom was a massive and largely clandestine land grab. "Sometimes this was achieved by so-called land mafias," Dasgupta writes. "But often the land grab was enacted by the state," thanks to the repurposing of an old law leftover from the British colonial era.

> Land was repossessed under an authoritarian law, little or no compensation was given to the people who previously made their living from it, and it was sold on, often at ten times the price, to corporations, which then used it in ways that actively destroyed the living of that place— employing the former landowners, now conveniently destitute, as construction workers, miners, and factory labour. Farmers who protested against the forcible acquisition of land for the purposes of Special Economic Zones

or automobile factories sometimes found themselves jailed or, in extreme cases, shot. But such a large-scale and devastating revolution could not proceed without widespread resistance. At any one point there were hundreds of protests across the country over land appropriation. Most distressingly for the political establishment, an armed Maoist rebellion swept the country's most devastated rural regions, and in many places usurped all state control.

Those are the wars that followed Niyogi's assassination. And for a time, until they were surpassed by the conflict raging in Odisha, they were most violent in Chhattisgarh.

Back home in Saket, Kanwar read two papers every morning and then walked over to his father's house and read six more. Throughout the 1990s, he scoured the news for items about meetings among politicians, administrators, and the representatives of multinational companies taking place in locations that were unlikely destinations for any of them to visit. Kanwar began clipping these stories, especially the ones about memorandums of understanding being signed in these areas. He began organizing them into clusters according to their location. The piles grew highest for five areas: the alpine forests in the Eastern Himalayas, the shores of Gujarat, the iron-rich areas of Bastar, mangroves and ports along the coast, and, finally, the Eastern Ghats, the mountain range running along India's eastern edge, including Odisha.

Located east of Chhattisgarh, the Indian state of Odisha (known as Orissa until 2009) has a population equal to Spain's and is the size of the US state of Georgia. Much of it is mountainous and forested, with rivers cutting through deep valleys.

The hills of Odisha hold bauxite, chromite, iron ore, and coal.
Much of the land is being wrecked by industry. Some two thou-
sand years ago, Odisha was home to the ancient kingdom of
Kalinga, which was distinct for the artistic inclinations of
its people, their openness to trade, and their propensity for
travel. The oldest traditional dance form in India dates from
that era. The emperor Ashoka, from the kingdom of Mauryan,
invaded Kalinga in 262 BCE, setting off a war so long, brutal,
and arduous that, as the story goes, Ashoka committed himself
to Buddhism in its aftermath, never sacking another territory
or waging another war in his lifetime.

Home to a wealth of antiquities, including historically
significant temples, forts, rock-cut architecture, and cave
paintings, Odishan cultural heritage rests on a long, multidisci-
plinary lineage. The New York–based filmmaker Mira Nair was
born there and raised in the state capital, Bhubaneswar. Liter-
ature in the Odia language is rich in novels, short stories, and
epic poems. Gopinath Mohanty, who arrived as a civil admin-
istrator in 1938, was especially adept at capturing the textures
of indigenous life in novels such as *Paraja* (1945), which follows
the members of a single family through a wider pattern of vil-
lage festivals, celebratory songs, wild hunting expeditions, and
the rise and fall of the seasons, which swing from plentiful and
abundant to forcing people to scavenge for stray tubers to sur-
vive. But the hardships of the time were nothing compared to
the damage being done to tribal life and land in Odisha today.

The novelist Arundhati Roy is particularly interested in the
fate of tribal communities such as Dongria Kondh, whose land
in the Niyamgiri hills of Odisha have been sold to a mining com-
pany named Vedanta.

52 If the flat-topped hills are destroyed, the forests that clothe them will be destroyed, too. So will the rivers and streams that flow out of them and irrigate the plains below. So will the Dongria Kondh. So will the hundreds of thousands of tribal people who live in the forested heart of India, and whose homeland is similarly under attack.

In their book, *Out of This Earth: East India Adivasis and the Aluminium Cartel,* Felix Padel and the Odia writer and filmmaker Samarendra Das calculate the value of bauxite reserves in Odisha's Niyamgiri hills at $2.27 trillion, as of 2004. In 2009, Roy updated the number to $4 trillion. The Indian government characterized the forces of resistance to industrialization into a terrorist threat, launching "Operation Greenhunt" and rounding up many artists, activists, journalists, and witnesses in addition to members of the armed Naxalite militias.

Eventually, some of the nonviolent protests yielded results. In 2013, the Indian Supreme Court ordered the state government in Odisha to give the tribal people of the affected villages the right to decide for themselves whether to accept or reject the mining company's plans. Twelve village assemblies, or *gram sabhas*, were convened. They unanimously rejected Vedanta's proposals, and demanded the company halt its work. Since then, Vedanta has tried to find ways around these referendums. In 2016, the state government asked the Supreme Court to annul the decisions of the village assemblies and convene new ones. The Supreme Court refused.

Kanwar began going to Odisha in the late 1990s. He made friends, taught filmmaking informally, and shot hours upon hours of footage. In Delhi, he had worked for many years with

the cinematographer Dilip Varma and the editor Sameera Jain. In Odisha, Kanwar expanded that team to include filmmaker Sherna Dastur and the journalist Sudhir Pattanik, of the political journal and Bhubaneswar media center known as Samadrusti. The result of their collaboration is *The Sovereign Forest* (2012), an ongoing, open-ended work began with a single film, *The Scene of Crime* (2011), and grew to include a collection of three large homemade books on banana fiber paper, videos that are projected onto their pages, six smaller digitally printed books, walls covered by maps and archival photographs and newspaper clippings and community documents, and a vast, nearly funereal display of thousands of seeds from the 272 varieties of rice that were once indigenous to Odisha. (Today, local rice paddies are dominated by about twenty high-yield varieties that cannot withstand the weather and require huge amounts of water.) There are children's drawings, details about leaves and plant life, photographs of fires and graves, and an open invitation to contribute new forms of evidence to the work. There are also materials related to the assassination of Niyogi, including a full transcript of the micro-cassette Niyogi made foretelling his own death.

By far Kanwar's most ambitious artwork to date, *The Sovereign Forest* debuted in 2012 at Documenta 13. It has been shown in nearly a dozen cities since then, including Abu Dhabi, Edinburgh, Houston, Mumbai, Madrid, and Vienna. For four years, it resided in the warehouse Samadrusti used as an office in Bhubaneswar, where people began adding to it, bringing their evidence, and having their materials discussed, documented, and studied. There are plans to install *The Sovereign Forest* permanently in a rural part of Odisha, in collaboration with a local organization or trust.

"Everything is always tentative," Kanwar said recently. "We are in a terrain of conflict, of depravation, of ecological and livelihood destruction, and acting in this terrain is fraught with contradictions and dilemmas. We try to address these, and to do the best we can without harming anyone, supporting as many people as we can, and are always learning through the process." His intention for *The Sovereign Forest* was to explore more fluid institutional forms. "I have worked with, been a part of, and seen various kinds of collectives over the last several years," he added. "I've seen their life stories, the conflicts that have emerged, their incredible strength and disintegration, too." He said he was constantly trying to understand cooperation and collaboration, to learn from past failures. Collectives could be a process, he concluded. They could be invisible. They did not need to be named or formalized, and, in fact, it might be better if they weren't, or if they remained unknown.

The lines running through Kanwar's oeuvre, from *A Season Outside* to *Such a Morning*, are direct and crystal clear. But the latter film operates almost entirely on the level of suggestion. *Such a Morning* is far subtler than *A Season Outside*, and it demands more from viewers. Characterizing Kanwar as "a metonymic image-maker," critic Sean O'Toole has written that his films "are driven by an internal logic that aims to connect with audiences experientially, rather than bludgeon them intellectually, as is so often the case with documentary films. Editing and narrative construction are central to this process."

It is some kind of irony that the forces of globalization, which are, at their most destructive, bringing chaos to the state of Odisha, are also, at their most creative, bringing the lessons of local resistance to audiences all over the world, via the

channels, networks, and resources of contemporary art. Just as
there is a clear line from *A Season Outside* to *Such a Morning*,
there is another between *Lal Hara Lahrake* and *The Sovereign
Forest*. Kanwar told me that the experience of 1991 is a kind of
counter-reference within the world of *The Sovereign Forest*, and
a reminder of justice being completely sabotaged. "If you are
responding to globalization in the 2000s and 2010s using the
tools of the 1990s, you know you can't fight in the same way.
The system is fixed against you," he said. "The only person left
who can do something is either ready to be destroyed or is very
strong. As an artist, how do you get into this? How do you inter-
vene? If the game is fixed, how do you play?"

What Kanwar learned from Niyogi's funeral still applies to
all of his work today:

Whether you are in a conflict inside a family, or whether
you are in a conflict in a large sense with people you don't
know, there is an intimate terrain of violence and what it
does to you. . . . But it was very clear to me that what was
actually of importance, apart from what happened, was
this terrain. It was also very clear that there was no way
that I had the ability or the capability to enter that terrain
or talk about that terrain. I had what I later had to describe
as a mixture of doubt and inadequacy, and a lack of com-
prehension. In hindsight, these are the key.

You have to get in touch with your own doubt, fear, and
confusion. And you have to address the complexity of each
person sitting in the audience. If I want to connect, then
I need to connect my own multiplicity and complexity to
theirs. If I could do that, then I'd be able to resonate with

another person. If I listened in a certain way, I could relate to the complexity of another person. It would start to create a more multileveled terrain and allow a conversation to take place.

Kanwar's aim is to create artworks that make demands of viewers but also encourage the shifts and exchanges that could lead somewhere else, from one person's complexity to another's, from one country's terrain of violence to yours, or to mine.

Fifteen years ago, *New York Times* art critic Holland Cotter reviewed a gallery show of *A Season Outside.* Assessing the toughness of the subject matter, the violence of partition, and the volatile legacy of historical trauma, Cotter asked the question: "Can extraordinary art be made from such raw, unresolved, living material?" and then offered the answer: "It can, and Mr. Kanwar is making it." But his work also does more than that. It brings the violence of seemingly remote conflicts and the acts of imagination being used to resist them into the minds of audiences who might never have known about them otherwise or been able to recognize what was happening.

Teresa Margolles

Part Two

Silence Rules,
Venice

There was really only one rule, and it was clear from the start. You were to enter the exhibition in silence and maintain it until the end. Artist Teresa Margolles, curator Cuauhtémoc Medina, and the team of nearly fifty people who had worked together on the show were all adamant on this point. Many of them were often present in the venue, over the six months the exhibition remained on view after opening in June 2009, as the materials of Margolles's art permeated the rooms, hallways, and stairwells of the run-down Palazzo Rota Ivancich in Venice and then drifted out into the city through actions, exchanges, and small objects given away as gifts. Whoever breezed into the building, whether they were friends or acquaintances or total strangers, was stopped in the entryway at a spare reception desk made of Brutalist concrete. Perhaps they were given a catalogue, some press materials related to the show. And then they were carefully instructed: "Please, no talking as you go through the exhibition. After you finish, then we can talk. Those are the rules."

Margolles and Medina had conceived of the show for the Mexican national pavilion of the Fifty-third Venice Biennale, one of the oldest exhibitions of its kind in the world, which critic Lawrence Alloway described in 1968 as an institution, a carnival, an extravaganza, "a vivid array of national self-images," and one in a small number of large public exhibitions responsible for the democratization of art. It was a shock to Margolles and Medina when a jury of museum directors, government functionaries, and curatorial peers selected their project from a pool of eight proposals, and they were given the go-ahead to do what was effectively a state-sponsored commission to be carried out for an international audience. Their idea, to orchestrate an exhibition titled *"De qué otra cosa podríamos hablar?"* ("What Else Could We Talk About?") as a provocation to address head-on the dramatic surge in violence that had overwhelmed many aspects of social, cultural, economic, and political life in Mexico in the first decade of the twenty-first century, was purposefully undiplomatic.

Founded in 1895 with an explicitly international agenda, the Venice Biennale is nonetheless organized along nation-state lines and routinely described as the Olympics of art. Mexico had participated with a national pavilion only twice before, first in 1950 with the muralists José Clemente Orozco, Diego Rivera, David Alfaro Siqueiros, and Rufino Tamayo, and not again until 2007, with an esoteric exhibition of interactive digital art by Rafael Lozano-Hemmer. In the run-up to 2009, the country was suffering a serious public-image problem in geopolitical terms. Two years earlier, the newly (and narrowly) elected president, Filipe Calderón, had declared a disastrous war on Mexico's drug cartels, deploying a fourth of the country's military to fight organized crime and staunch the violence of the drug wars.

60 Calderón's campaign was an unmitigated failure. Throughout his term the cartels slaughtered each other ever more spectacularly, exposed military corruption and police incompetence, amplified a culture of narcoterrorism for all the world to see—and then emerged not only structurally intact but vastly more powerful than before, epitomized by the staggering rise of Joaquín "El Chapo" Guzmán, a hitherto mid-level trafficker who became one of history's most powerful drug lords.

At the end of 2008, Calderón secretly instructed Mexico's corps of ambassadors and consular staff to convey the notion and "to claim proudly" in public that Mexico had won the war and achieved lasting peace. Six months later, Margolles and Medina arrived in Venice with a bombastic retort to that mission. As Medina explained, the proposal for Margolles's exhibition was "a visceral reaction to the expectation of the Mexican elites that for the sake of the national image, or to safeguard the illusion of tourism, we should maintain a contrite silence about the indiscretion of a society bent on slaughter in such a noisy, immoderate and public fashion. They wish."

Margolles, who was born in 1963, had taken an unusual path to becoming an artist. By the 2000s, she was already a well-known figure, both in Mexico and increasingly abroad. Her original interest was photography. As a girl growing up in the north of Mexico, in a region of Sinaloa blasted by extreme heat and drug trafficking, she learned to take pictures in a documentary mode. After moving to Mexico City, Margolles studied political science, communications, and later forensics at the Universidad Nacional Autónoma de Mexico, or UNAM, the capital's enormous public university. She sold books outside of the university gates, taught photography classes on the side, and

gravitated toward thrash music and hard-core punk. She started a death-metal band influenced by the Viennese Actionists and German Krautrock, which sounded better to her ear when it was played harder, faster, and louder. The plan for the band, whose members were fellow UNAM students, was to stage just one, never-to-be-repeated performance on April Fool's Day, 1990, in La Floresta, a famous but abandoned and half-destroyed psychiatric hospital in Mexico City.

"We wanted to drink beer, play music, read medical stories, and make things for the camera," Margolles told me in the summer of 2018, when we met in Madrid. "We wanted to push the limits." Margolles didn't sing or DJ or play a musical instrument. Her tool was her camera. She was using an early Canovision camcorder at the time and thinking about a lineage of filmmakers from Luis Buñuel to Rainer Werner Fassbinder, as well as the theater of Antonin Artaud and Alejandro Jodorowsky's Teatro Panico. "We wanted people to live the performance," she said. But instead of dissolving the band as promised after that one momentous show, Margolles and the others carried on. The group evolved into a collective, which thirty years later is still regarded as one of the most influential experiments in the history of contemporary art in Mexico City. SEMEFO, named after the acronym for Servicio Médico Forense (Forensic Medical Service), galvanized local audiences for a decade. Through their use of animal cadavers procured from unlicensed butchers and the remains of human corpses borrowed from the Mexico City morgue, they cultivated a very particular aesthetic—totally gothic, literal to a fault, and obsessed with blood and gore.

SEMEFO was always controversial, but the group's work was celebrated in museums and galleries with surprising ease.

62 They showed their work in renegade spaces such as La Panadería as well as in mainstream venues such as Museo del Arte Carrillo Gil. Held together by seven friends and some two dozen collaborators, the group created sculptural, durational installations involving the guts of a cow stitched into a sofa and a display of tattoos that had been cut from dead bodies and stretched over heat-intensive light bulbs so that the pieces of skin dripped beads of fat and melted. Medina remembered seeing an early SEMEFO performance, which he described as "very messy and gothic and extreme. There was a woman with the face of a pig and a strap-on penetrating another member of the group."

But more than just sensationalism and shock value, SEMEFO was articulating a trenchant critique of institutional spaces—such as schools, hospitals, and the morgue—where it was possible to see the ways in which society was being utterly transformed by the violence coursing through Central and South American in the 1990s.

When SEMEFO came to an end in 1999, a clear line extended from the quieter, more sepulchral work of the collective to the aesthetic that Margolles cultivated on her own. For example, SEMEFO's *Catafalco* (Catafalque) featured two full-sized plaster casts of dead bodies made on the autopsy table in the morgue. They were exhibited standing upright, ghostly and regal, with traces of hair, skin, and other organic matter still stuck to the hollowed-out furrows of gypsum. Another series, titled *Dermis* (Skin), consisted of ten large bedsheets, impressed with the bloodied silhouettes of still more corpses. When hung in an exhibition space, the sheets were repurposed as haunting and eerily expressionistic paintings. One of them bore the

impressions of two men, described by scholar Rubén Gallo as "gay lovers who had taken their lives in a double suicide."

The two series, credited to the collective, were included in *"Muerte sin fin"* ("Death Without End"), Margolles's first major museum show, held in Germany in 2004. There, creating a seamless narrative, the SEMEFO works were presented alongside *Papeles* (Papers, 2003), Margolles's series of stained, swirling, monochromatic works on paper, arranged on the wall, pinned in place and left unframed, in a pseudo-modernist grid. Each piece of Fabriano paper had been soaked in the water used to a wash a corpse after an autopsy, which was discernible only upon reading the wall labels. Artist Santiago Sierra, a longtime friend of Margolles's, described her solo work after SEMEFO as "profoundly evocative and silent, tending to induce sadness rather than the noisy curiosity."

Medina, meanwhile, was (and is) one of the most important curators of his generation, as well as a critic and columnist for the Mexico City newspaper *Reforma*. Born in 1965, he had been studying outside of Mexico for most of the SEMEFO years. He was defiantly leftist, an agile thinker, generous with his time, deeply partisan in a factional art scene, and a great champion of subversive artistic strategies. Medina saw in the competition for the national pavilion a chance to bring a more complicated knot of ideas and experiences to bear. When he was invited to submit an idea and asked Margolles to collaborate, they assumed they had no chance of being chosen. They were writing a proposal to be filed away—but registered as an act of protest—in the cultural archives of the state. Then, in a complete surprise, their project won the competition.

When Margolles and Medina arrived in Venice, they decided to implement a strict sense of atmosphere. Anywhere in Venice can feel like a circus in the high tourist season. The opening days of the biennale easily devolve into media spectacle, with the attention spans of viewers totally atomized until some outrage trains their focus. Margolles and Medina were quick to counter all of that with a rule transforming the experience of the exhibition into a ritual, something more like a funerary rite, an occasion of real solemnity and seriousness that demanded, above everything, respect.

Jammed up against a putrid canal in the Castello district of Venice, accessible via an absurdly narrow street around the corner from the Fondazione Querini Stampalia, a small but beloved museum, the Palazzo Rota Ivancich is a sixteenth-century amalgamation of two combined buildings spread over three stories that are all structurally sound but in varying states of decay. For Margolles and Medina, it was never their choice. They inherited the site from the pavilion's administrative and institutional organizers. Because Venice is essentially "an over-protected world heritage site," they were extremely limited in terms of what they could do with the building. They couldn't hang anything on the existing walls, for example, and all of their exhibition plans had to pass stringent health, safety, and heritage reviews. Margolles decided to leave the palazzo exactly as it was and to slip her works into the site as she, Medina, and their colleagues had received it.

For those reasons, as viewers walked through her exhibition in silence, they were often rattled by the sensation either that they were missing out on everything or that what they were looking at amounted to almost nothing. You entered the

venue, climbed an old set of stairs, and found your way through a warren of grand, disheveled rooms. The ceilings were high. Some of the walls were covered with intricate moldings, others with torn burgundy tapestries. The floors alternated between terrazzo and parquet. There were intricate wrought iron railings, ornate mirrors, an excess of original detail. Everything in Venice already carries suggestions of wealth, pleasure, and ruin. As you moved through the cavernous spaces, the dimly lit hallways, up and down the narrow stairs, the entire building began to feel damp, and you started to notice the smell, faint but cloying, and not coming from the canal.

In one of the upper rooms, you might have noticed the presence of someone in jeans and a black T-shirt, who was slowly, methodically, mopping the floor. Then you realized that all of the floors were wet, and the smell was coming from there. In another room, between the flags of the European Union and the Republic of Venice, you came upon a third flag, unfamiliar, made of rough-hewn canvas and colored a rich, dark red. In yet another room, more flags of red-stained canvas, were strung up like monochromatic abstract paintings, monumental in their scale but loosened from their frames. A handful of women, part of the exhibition team, were there to guide you through the space. None of them spoke, and none of them smiled. And then the exhibition shifted. You passed by a small safe lodged into a palazzo wall long ago. Inside was a collection of gold jewelry set with small pieces of glass. Down an interior staircase you found more large canvases, less red this time, but weirdly dripping and covered with what looked like mud and concrete. It was the same as the concrete of the reception table in the entryway, to which you now found yourself swiftly and abruptly returned.

66 The wall texts told you that the floors of the palazzo were being mopped with the blood of crime scenes in Mexico, blood which had been absorbed by large swaths of fabric, dried, transported to Italy, and rehydrated with local water (just enough to pass the sanitation review); that the canvases you saw had been used to wipe up the sites of executions, caked in the mud of Ciudad Juárez; that the jewels were pieced together from shards of glass left over from the windshields shattered in drive-by shootings in Culiacán; that the concrete reception desk was made from the fluids gathered from the places where people had been killed.

Also, in riffling through the press materials—absorbing the blow-by-blow disturbances caused by the brief, explanatory texts, all carefully written by Margolles, which accounted for half of the work's power—you discovered that you were also in possession of a small card. It was the shape of a standard credit card. It also looked like your entry pass to the biennale. On one side, you found the biennale logo and a magnetic strip. On the strip itself, it read: "Card to cut cocaine." On the other side, a lurid photograph showed the bashed and bloodied skull of a corpse laid out on a perforated metal tray. It was the face of just one of the more than five thousand people killed in Mexico that year in narco-related crimes.

And that was not all. Among Margolles's team were the relatives of people who had been killed. They were there, mopping the floor of the palazzo, part of a sustained performance piece titled *Limpieza* (Cleaning). They were there, posing on Venetian bridges, wearing the gold and glass jewelry made by Sinaloa artisans in the *narcocultura* style of their clientele, featuring the face of Jesus Malverde, a folk hero for one set of drug traffickers, and

the skull-centric imagery of the cult of La Santa Muerte, favored by another. The jewels themselves were called *Ajuste de cuentas* (Account Settling), and the act of wearing them, *Paseo de las joyas* (Jewels Promenade). And the relatives were there, again, sitting in the streets of Venice with embroidery hoops in their hands, stitching shimmering gold thread into the canvases soaked in the blood of execution sites, for the performance *Bordado* (Embroidery). Like talismans in reverse, their stitching spelled out the messages sent by the murderers to the victims' families, warning them against revenge killings: "See, hear and silence / Until all your children fall." When the embroideries were done, the canvases were returned to the rooms of the Rota Ivancich and hung as paintings, titled *Narcomensajes* (Narcomessages).

All of it was completely over the top, one horrific revelation after another. More bloodstained canvases had been plunged into the sea and then dragged across a beach on the Lido, the long, thin island separating the Venetian lagoon from the Adriatic Sea. Still more bloodstained canvases had been hung on the façade of the stately, neoclassical US pavilion, located in the middle of the Giardini, Castello's sprawling gardens, blacking out the windows and doors of the building. That action was carried out a month before the biennale opened. The canvases were put in place, photographed, and removed as part of a "secret" artwork titled *Embajado* (Embassy), which existed thereafter only in pictures, stories, and rumors. And lastly, the sounds, *Sonidos de la muerte* (Sounds of Death). Audio recordings gathered from more execution sites in northern Mexico haunted your otherwise quiet path through the palazzo.

Margolles and Medina had imposed so many rules to create an atmosphere of terse but respectful mourning that, in the end,

68 it was as if their project had wound down the noise of the world so low that it was possible to hear only the deep, rumbling, mechanical sound of a conflict grinding on and on.

Now you were done with the exhibition. There was blood on the bottom of your shoes. It would soon be ground into the cobblestones outside, dirtying the streets of Venice with the refuse of Mexico's grueling violence. Now you could talk again, even ask the members of the exhibition team some questions. But, by that point, most viewers were speechless.

More than a decade has passed since Margolles's exhibition for the Mexican pavilion. Ask around and you'll find that for those who were there, it was and remains one of the most bracing encounters with contemporary art they've ever experienced.

Although Venice marked a turning point for Margolles, "What Else Could We Talk About?" was poorly received in official quarters. Against protocol, not a single representative of the Mexican government attended the exhibition. The logos of Mexico's Ministry of Foreign Affairs and one of the supporting institutions were removed from all of the exhibition materials, including the catalogue. At least two members of the jury that had chosen Medina and Margolles for the pavilion were removed from their positions, including a prominent museum director and a ministry official who was exiled to a lesser post. After the biennale, whatever plans there had been to stage "What Else Could We Talk About?" back in Mexico were dropped. For years, contemporary artworks dealing with the drug wars became a kind of local taboo.

Margolles had lived and worked as an artist in Mexico City throughout the 1990s and 2000s. But after 2009, her career took off almost immediately, and a heap of awards, honors, and

prestigious exhibitions followed. She was able to pull off ever
more elaborate and ambitious projects, and she shifted her base
to Madrid. "What Else Could We Talk About?" had stirred up
acrimony and ill will. "There was a certain beauty, to see the
fabrics, to see the performance of people cleaning, to see the
person stitching outside in the streets. But you must under-
stand that this was in all the press in Mexico," Margolles's gal-
lerist Peter Kilchmann told me. "She was worried about her
family, she was worried about her mother, she was worried
even about traveling around."

Digging In,
from Culiacán to
Mexico City

The north of Mexico, Margolles told me, is a place of extremes. "Culiacán is the hottest city in Mexico," she said. "There's no sea. The earth is hot. The cars are hot. Fruit ripens too quickly. Things decompose extremely fast. You move a rock and you see ants and spiders scurrying about. It's the same thing for all children in the north. You play in the street. You run around barefoot." When Margolles was growing up in Culiacán, there was obviously no internet. "On television we had just a few channels," she said. "We had too much freedom." Margolles remembered being especially curious about the life she discovered in the ground, digging around in the dirt. "But for the most important narcos in Mexico," she said, "Culiacán is their neighborhood." The city may be the largest in Sinaloa and the administrative capital of the state, but the more consequential fact is that Culiacán is the long-standing headquarters of El Chapo's cartel, which has survived his incarceration and continues to thrive. In the area where Margolles is from, "the kids of the

doctor, the narco, and the teacher all play together, only the narco's son has a motorcycle, the rest have a bike."

Margolles understands English but doesn't speak it, as a matter of political choice, her refusal to acquiesce to the dominance of the US. The first time we met in Madrid, she brought along a friend, a young professor from Ciudad Juárez who was two years into a two-month residency program in Spain, and asked him to translate. The second time, she did the same with a curator who worked in an art center not far from Margolles's neighborhood. Her working method, not only with visiting journalists but more importantly in taking on long-term projects, involves a constellation of people helping out with minor and major tasks.

In her photographs and videos, especially from the earlier days of her career, Margolles is often present. Her uniform rarely changes: long black braids, faded baseball cap, silver jewelry, overalls, a motorcycle jacket, big black boots. But there's hardly any sense of scale in the images Margolles makes of herself. Given the force of her work, the fortitude of her positions, and the fact that I'd never seen her in person before, I expected to find her physically intimidating, a towering presence—at the very least, I expected her to be tall. It was a surprise, then, to discover that she is in fact quite tiny, elfin, even pixyish, to the extent that I wondered if her unassuming size contributed to the way she gained access to otherwise closed communities and negotiated intimate and ethically complicated agreements with individuals and families to create some of her most difficult works.

Peter Kilchmann, who has worked with Margolles since the late 1990s and whose gallery in Zurich has represented her

72

for decades, told me that people sometimes misconstrued her small stature and her stance on languages, assuming she was some kind of strange, eccentric, and noncommunicative creature. "Teresa is not an easy artist," he said, "but I really admire her. For what she has done in the past twenty-five years, she should be more recognized. It has to do with her technique, how she works. I mean, to have canvases full of blood is not everyone's thing. But she keeps on going and doing that. She doesn't care about the market."

When Margolles first moved to Mexico City, the contemporary art scene was still a relatively local affair. The market was small, especially for a megalopolis of some twenty million people. Commercial galleries hadn't yet synched into the international circuit of global art fairs. Sofía Hernández Chong Cuy, a curator who has worked with Margolles several times, remembered moving to Mexico City from Monterrey, in northeastern Mexico, and finding that the capital was the center of everything happening, where several artists there were exploring the topographies of the city itself. "The urban reality was very present in the kinds of works they were doing," she said. "Artists of the time were doing a lot of interventions presenting disparity— economic disparity, social disparity, class disparity—within their environment."

Those artists turned out to be the ones who drew international attention to the local art scene. When the curator Klaus Bisenbach organized "Mexico City: An Exhibition About the Exchange Rates of Bodies and Values," in 2002, a vast celebration of the city's artistic energy featuring works by Margolles and a catalogue text by Medina, among others, it was the first

time a major New York museum had devoted a show to modern
Mexico since Rufino Tamayo's survey at the Guggenheim in
1979. A key factor attracting such interest was the social life the
artists of that generation shared. "You go to a party," one artist
recalled, "you bump into people, and you share your ideas. And
those ideas get built with other people and they connect you
to other people." It was that communal spirit that initially held
SEMEFO together, underneath the aggressive effect of their art.

Several of the collective's early works incorporated the
cadavers of horses, mules, and unborn foals. In one such piece,
several dead and emaciated horses were strung from a makeshift
carousel. In a landmark sculpture titled *Teul I: Lavatio Corporis*
(Teul I: Washing of the Body), 1994, a horse was tied with thick
rope to a rig of wooden scaffolding that resembled a giant chair.
The horse was positioned upright, as if raised on its hind legs,
its head thrown back in fury or anguish. The entire assemblage
rested on a square of dirt. As Á. R. Vázquez-Concepcíon has
pointed out, the composition was based on a famous painting
from the 1940s by José Clemente Orozco, one of the major art-
ists of the Mexican Revolution. Beyond the gore factor and
transgressive subcultural aesthetic, *Teul I* established a his-
torical lineage tying the art of SEMEFO, a group responding to
political, cultural, and economic struggles in the present, to
an older work, a precedent, reacting to the violent rupture of
the revolution, and before that, to the bitter fight for Mexico's
independence from Spain, which was the subject of Orozco's
painting. *Teul*, as Vázquez-Concepcíon noted, was "a deri-
sive Aztec term used to address the Spaniards, and the horse is
famously a symbol for the forces of colonialism."

74 Some argue that SEMEFO's work was necrophilic, that a sexual undercurrent coursed through the collective's performances, sculptures, and installations. Others say that they were thanatophilic, driven by death as the height of all beauty, tinged with abjection. Still others argue that SEMEFO's work provided an important critical expression of the necropolitical, a body of political and social thought articulated most succinctly by the Cameroonian philosopher Achille Mbembe, building on the work of Michel Foucault, in which state sovereignty in the late twentieth and early twenty-first centuries is no longer determined by who guarantees the rights of citizens but rather by who claims the authority to kill them, or to reduce them through poverty, extreme labor exploitation, and perpetual war (whether the war on drugs or the war on terror or the war on refugees and immigrants) to a state of living death.

Whatever the case may be, SEMEFO's members eventually, and perhaps inevitably, grew apart and moved on to other things. As a bookend to the group's first performance in La Floresta, on April 1, 1990, SEMEFO's last performance took place in Santiago de Cali, Colombia, on August 30, 1999. Titled *Andén* (Sidewalk), the piece began when the group put up notices in the streets of the city inviting people to participate in a ritual action. Colombia in the 1990s had effectively been in a state of civil war for more than thirty years, with leftist guerrillas fighting the US-backed military and everything complicated by the introduction of drug-trafficking and organized crime. Millions of people had been displaced from their homes and thousands of children had disappeared. SEMEFO asked the survivors to bring to a public park known as Las Banderas the belongings of people who had been kidnapped or killed. The group's

members dug up a sidewalk in the park, and for eight hours, people came and placed these belongings into the wide, opened trench. Then SEMEFO closed up the trench, repaired the sidewalk, and brought the decade-long experiment of their collective to an end.

Margolles had become acquainted with several eventual members of SEMEFO, and made friends with Medina, while she was selling used books outside of the humanities department at UNAM. Her department shared a parking lot with UNAM's medical school. In those days, Margolles was influenced by the work of an older artist named Alejandro Montoya, who had been incorporating human remains into his art since the 1980s. Margolles, still a photographer, was interested in taking pictures of dead bodies.

This went beyond a self-evidently gothic disposition. As Rubén Gallo explained: "The decade of the 1990s was one of the most turbulent periods in recent Mexican history, marked by political assassinations, the Zapatista uprising in Chiapas, the signing of NAFTA, a catastrophic economic crisis, and the defeat of the Institutional Revolutionary Party (PRI), after seventy years of one-party-rule." Some artists reacted by making work that had nothing to do with these political upheavals. Others, like the members of SEMEFO, took the opposite approach, responding to traumatic events with bold, even outraged experimentation. As crime in the country surged and the divisions between rich and poor widened, Margolles became increasingly fascinated by the anonymous corpses that the medical school students were using in their classes. Where did they come from? Why hadn't they been retrieved by their families and given proper funerary rites? Who designated these

76 bodies for medical science and what happened to their names
 and stories?

 Margolles crossed over to the other side of the parking
 lot and began what she described as her clandestine studies in
 forensic science. Those were followed by formal studies, and an
 official diploma in forensic pathology, which brought her into
 the space of the central Mexico City morgue. There, unlike in
 UNAM's medical school, the dead bodies did have names and
 stories that were known. In addition to case studies, she learned
 all of the processes of a body's decomposition, how to investi-
 gate a corpse, and the differences among a corpse, a cadaver, and
 a carcass.

 "When Mexico became a violent country," Margolles told
 me, "you could see it in the bodies in the medical school. You
 could see it inside the morgue." She has often described the
 morgue as an index or thermometer of society, an instrument
 for measuring its ills. In a series of photographs from 1998,
 titled *Autorretratos en la morgue* (Self-Portraits in the Morgue),
 Margolles appears in a white lab coat, rubber gloves up to her
 elbows, over black jeans and a black long-sleeved T-shirt. In
 Autorretratos No. 5 (Self-Portraits No. 5), she holds the corpse of
 a twelve-year-old girl in her arms. The body is draped over her
 wrists in a gruesome approximation of Michelangelo's *Pietà*,
 and the girl appears to have been mutilated, slashed across the
 chest, and burned. Margolles is shot from above and off center.
 She regards the camera with a glowering look. In *Autorretratos
 No. 2* (Self-Portraits No. 2), she stands behind a corpse laid out
 on an autopsy table and rests a gloved hand on the corpse's
 waist. In *Autorretratos No. 4* (Self-Portraits No. 4), she poses

beside two corpses stacked one above the other, her arms folded
across her chest, hips cocked to the side.

In an early video from 1999, titled *Bañando al bebé* (Bathing
the Baby), Margolles washes the tiny body of a stillborn baby
boy. The mother was a friend of Margolles's. She didn't have
the money for a proper burial, although she wanted him to have
one. She donated the body to Margolles, who in turn created a
private performance (the act of washing), the video (as docu-
mentation), and a sculpture, titled *Entierro* (Burial), for which
she encased the corpse in a rectangular slab of concrete, like a
small minimalist tomb, or a movable grave. When *Entierro* was
later exhibited as a work of art in a gallery, the concrete began to
crumble and fall away from the body inside, horrifying viewers.

For another video, titled *Grumos sobre la piel* (Globs on the
Skin), Margolles traveled to Spain in the summer of 2001 with
a small bottle of human fat she had collected from the morgue.
Soon after arriving, she bought ecstasy from a drug dealer on
Barcelona's Plaza Mayor. It was laced with chemicals and it
nearly killed her. Then, some days later, as she was helping the
artist Santiago Sierra to install a show, Margolles ran into the
same drug dealer, named Mohammed.

> I told him what he had done to me, and he said, "Forgive
> me," and he thought I was going to demand my money
> back, but no one does that around here. Later we went
> back to the plaza where he deals and I sat him down and
> explained that I am an artist, and I showed him my work.
> He started to get scared and said, "What are you going to
> do to me?"

She asked him to be part of her work. The resulting video features Margolles rubbing globules of fat onto Mohammed's back, arms, and torso. "I was mad at the dealer, and I was still feeling bad, but when I started smearing the fat I wasn't angry anymore," Margolles said in an interview with Sierra for the magazine *Bomb*. "Later I figured out the piece: My misery is your misery. That's what it was all about. We don't level ourselves through purifying ourselves but rather through sharing our misery."

In 2000, the body of a young man turned up at the morgue in Mexico City. He was a drug addict, tattooed with multiple piercings, and he had been murdered. Margolles found the young man's body beautiful, his story both typical and terrible. She located his friends and family. None could afford to bury him or cremate his body. Medina described these negotiations as "ethically uncomfortable":

> With no hesitation, Margolles came up with a daunting proposal. She offered the mother a casket to pay homage to her son in exchange for a section of his corpse to show as a readymade. Margolles even suggested that she would like to acquire the man's tongue or penis, because both had piercings and therefore, metaphorically "spoke" about his defiance of social norms. These body parts would convey his claims of marginal and global contemporaneity—in short, his subcultural identity. . . . Her offer did not seem to offend the man's relatives and friends who, forced by circumstance and their belief that they were in some way commemorating the deceased, agreed to exchange his tongue for a metal coffin.

The preserved readymade is titled *Lengua* (Tongue). As
Margolles explained, the young man's body reminded her of a
defeated bull. She also discovered that he had been a singer in
a punk band. "I had to go talk to the family," she said, "but they
helped me because we understood each other. I work with emo-
tion, not reason."

Medina is correct to signal the ethical dilemmas of Mar-
golles's work. One could argue that making art from the sev-
ered tongue of a murdered teen or the entire body of a stillborn
child are examples of a extreme exploitation, taking advantage
of people who are already severely dispossessed. Margolles
doesn't shy away from those readings. But she demands that
viewers wade in with her and try to find clarity in a morass of
moral ambiguities. She asks that viewers see what she sees,
trust her instincts, and believe in her methods and materials.
From conditions of outrage or indifference, she tries to create
dignity, even while risking its opposite, shameless exposure.
She describes her work in terms of scratching on something
until she can dig deeper into it, obsessively but also perhaps
obliviously to the wider implications or possible misinterpre-
tations of what she is doing. It is relatively easy to conclude
that Margolles acts in poor taste. But after experiencing her
work, it is more difficult to deny the violence she has dug up to
show you.

Within Margolles's oeuvre, "ethically uncomfortable"
pieces like *Lengua* and projects such as "What Else Could We
Talk About?" tend to get the most attention. So do installations
such as *Vaporización* (Vaporization), from 2001, and *En el aire* (In
the Air), from 2003, for which the artist collected water used to
wash corpses in the morgue, sanitized it, and ran it through fog

80 and bubble machines, respectively, of the kind typically found in dance clubs. The water works, like so much of her art, depend upon two levels of engagement. First, you experience the material as it is. Second, you read the wall label or the accompanying text to understand what the piece is made of or where the material comes from, which thoroughly scrambles your initial response.

Describing her process, Margolles told me she begins with an idea or concept. "Then I think and I think until the medium comes. The idea comes first and then it moves until it knows the right medium." Since 2009, Margolles has continued to dig into the violence of the drug wars in Mexico, but she has also followed it elsewhere, into other territories and terrains of thought. She returned many times and made a number of important works on the Simón Bolívar bridge, which crosses the border between Colombia and Venezuela. She realized a series of formidable projects on domestic violence, involving embroideries on bloodstained fabrics done by women in six countries throughout the Americas, including the US in the aftermath of Eric Garner's death in a police chokehold on Staten Island in New York City. But the place that has emerged in her solo work as the most vividly rendered and complex of all is Ciudad Juárez.

Dreams of the Living, Ciudad Juárez

Before it was known as the world's deadliest city, Ciudad Juárez was a Spanish colonial settlement built around a tall cathedral and a pretty seventeenth-century plaza. Located at the edge of a desert plateau in a rich fertile valley, which was home to indigenous communities dating back twelve thousand years, Juárez is the oldest urban center on the border between Mexico and the United States. Ever since the late nineteenth century and the extension of railways into the area, Juárez, previously known as Paso del Norte (Pass of the North) and named for the former president Benito Juárez, has experienced dramatic cycles of boom and bust.

For a time, Juárez was considered the Las Vegas of Mexico. Local businesses were thriving thanks to an active nightlife sector and whole districts of popular casinos and jostling clubs. But the city grew too fast. International drug traffickers moved in and dramatically grew their business in the 1980s, when Ronald Reagan disastrously expanded Richard Nixon's "war on

82 drugs," and have been taking advantage of the chaos and dys-
function of Juárez ever since.

The signing of the North American Free Trade Agree-
ment, in 1994, allowed for a huge increase in the amount of
trade moving back and forth across the border. On the Mexican
side, NAFTA had the effect of forcing peasant farmers, manu-
facturers, and small business owners out of their jobs, which
disappeared in the flood of cheap imports and the oblitera-
tion of communal farmland, and into the employment of the
cartels—as drug smugglers, security guards, and assassins.
Later, the security forces that evolved out of the cartels and into
self-sustaining militias complicated the situation even fur-
ther by adding to the list of increasingly theatrical crimes—
including decapitation and the hanging of headless bodies from
trees, highway signs, and bridges—the killing and kidnapping
of migrants, who usually had nothing to do with drug trafficking
at all but were merely passing through Mexico from Central and
South America along some of the same trade routes heading
into the US. A dispiriting number of men formerly employed
by the Mexican military, police forces, and elite anti-narcotics
units now staffed the upper ranks of the cartels and their off-
shoot militias.

NAFTA had made it possible for a rush of new foreign-
owned factories and processing plants to open just over the
Mexican border in cities like Ciudad Juárez. These factories,
known as maquiladoras, allowed US and multinational corpora-
tions to assemble goods ever-more-cheaply by moving the dis-
parate parts of a given product back and forth across the border
at virtually no cost, paying very little for labor. The maquila-
doras were vast, charmless, and quickly built in the middle of

nowhere, often at the end of long access roads that ran only one way at a time, taking workers into the factory by bus for the start of a shift, and out of it at the end.

Women made up more than half of the maquiladora workforce. Factory owners were said to prefer them to men because they were more likely to accept low wages and less likely to unionize. Women from all over Mexico came north to take these jobs because they were poor, destitute, or had few other options. Some may have believed the promises of personal autonomy and economic empowerment. What they got instead were mandatory pregnancy tests and ubiquitous sexual harassment (the maquiladoras functioned largely outside of existing labor laws). And then the bodies of those women began turning up dead in the dirt of Juárez. Many of them had been raped multiple times, their bodies maimed, disfigured, and mutilated.

In the first decade after NAFTA, more than three hundred women were murdered in Juárez. Nearly four hundred were killed in 2010 alone. Some of the deaths were connected to the drug trade. Others were thought to be the work of one serial killer or many. Around this time, Margolles began to meet the relatives of women who had disappeared, been kidnapped, or fallen victim to femicide in and around Juárez. She befriended mothers, sisters, friends, migrants, and maquiladora workers. The installation of missing persons posters on glass rattled by the sound of the freight trains in *La búsqueda* is at once a testimony, an act of protest, and a memorial to the murdered women. The posters may be faded and torn, but someone has taken the time to make them, someone tormented by the disappearance of loved ones, someone willing to call out their names. In this way, Margolles outlines the lives

84 that have been stolen but she also sketches in the lives that have been left behind, crippled by events and circumstances but still somehow surviving.

In his harrowing five-part novel 2666, published posthumously in 2004, Chilean writer Roberto Bolaño also names them in a brutal passage of nearly three hundred pages, titled "The Part About the Crimes." Bolaño describes one killing after another, beginning with the discovery of the body, in the manner of a police report or a forensics record. All of the murders are set in and around the fictional city of Santa Teresa, a stand-in for Ciudad Juárez. Woven into the stories he tells about the women are the accounts of the hapless, melancholy police investigators—at the end of "The Part About the Crimes," three murder cases are closed after only half-hearted investigations. As in the world of the novel, the crimes were never solved in real life. Neighborhoods were emptied as inhabitants decided to leave a city condemned to a miserable fate. Real-estate speculation and the razing of red-light districts for future development further destroyed the urban fabric. According to a study by UNAM, some 220,000 people have been displaced and 115,000 homes have been abandoned in Juárez. Those left behind included the staffs of once lively clubs and casinos and tight-knit communities of transgender sex workers.

In 2005, Margolles created an installation called *Lote Bravo*, made from a collection of five hundred bricks, which were shaped from the mud Margolles had gathered from sites where women's bodies were found buried in Juárez. As objects, the bricks have been displayed stacked up together to form a

wall, or standing one by one, evenly spaced on the floor, like
gravestones in a cemetery. The idea isn't that each brick cor-
responds to a victim or even a unit of victims, for an accurate
accounting of the dead. Taken together, they convey the enor-
mity of the violence against women in northern Mexico, as well
as the need for adequate mourning rituals and the restoration
of dignity. Another iteration of the brickwork, titled *La Gran
America* (The Great America), 2017, consists of a thousand cob-
blestones made from the mud of the Rio Bravo riverbed and pre-
pared according to ceramics techniques discovered at Paquimé,
an archeological site in the state of Chihuahua, where Juárez is
situated. Margolles teamed up with a local artisan named Israel
Gómez to make the stones.

Some years later, Margolles bought a house in Juárez that
had previously been used for social welfare and stood in a
neighborhood surrounded by maquiladoras. With a team of
people, she destroyed the house over eleven days and ground it
down to gravel. The gravel, weighing twenty-two tons, has been
transported to various exhibition venues, where it is recom-
posed in a long, low slab, which a performer chips away at, day
by day, for the run of whatever show it is a part of. Back in
Juárez, a cultural center was built on the site of the destroyed
house. This is all part of Margolles's larger project. A major
piece of that work, titled *La Promesa* (The Promise), 2012, con-
sists of the testimonies of people who lived there and used the
space as a refuge.

In 2010, Margolles saved the front page of the afternoon
paper *PM*, a tabloid in Juárez, every day for a year. The resulting
work, titled *PM 2010*, 2012, has been shown as a square of street

86 posters, as a timeline wrapping around a room, and reproduced
as an anthology in a book. As a newspaper, *PM* is notable for
several reasons. It has no website and there are no archives, dig-
ital or otherwise. Every few months, the papers are destroyed by
the publishers. (An alarming number of journalists have been
targeted and killed in Juárez.) One reason for this is that the
paper creates a record of the murders in Juárez, placing the news
of each new killing (or multiple killings) on the front page next
to pictures of pinup girls and advertisements for brothels. Mar-
golles's work isn't about the sexual fascination with death. It's
about the sexual dimensions of the drug wars, in which women
and those identifying as women have been reduced to one more
category of goods to be trafficked.

When Margolles first started going to Juárez, she was
approached one day in the street by a woman who wanted to
know why she wasn't doing anything about her. The woman,
named Karla, mistook Margolles for a Spanish journalist, and
she wanted to tell her at length, at that moment, that the center
of Juárez was being destroyed. Karla was one of the many trans-
gender sex workers left behind in Juárez. Their world was a dif-
ficult one for Margolles to enter. But she did, and for several
years, she has made an expanding number of extremely moving
works about their community, including the series of photo-
graphs titled *Pistas de baile* (Dance Floors). Each photograph is a
portrait of a trans sex worker posed on the remains of the dance
floor of a club (and former employer) that has been demolished.
Some of the dance floors are muddied, others surrounded by
bulldozed gravel. At least one is washed in blood. The women
appear tiny in these wasted landscapes, and when Margolles

gave each of them a print in return for their time, the women were hilariously outraged that they didn't appear bigger in the frame. To look through the series and read the titles is to hear the lilt of their names and their radical acts of self-invention: Andrea, Berenice, Cuca, Galdy, Jacqueline, Karla Ivonne, Marlene, Nancy, Osiris, Paloma, Patty, Sansara, Scarlett, Valeria, Vanessa, and Vivianne.

One of Margolles's later series of photographs, titled *This Property Won't Be Demolished*, 2009–2013, focuses on the lonely buildings that have been left standing among the many destroyed, documenting the situation Karla initially told her about in harrowing portraits of devastation and neglect. Another series, titled *El Testigo* (The Witness), 2013, captures the gorgeous old trees of Juárez, their bark chipped and dinged by bullets whizzing past them. Margolles has spelled out the suicide notes of teenagers on the marquees of abandoned movie theaters. She has recorded children screaming, followed by silence, to show, unexpectedly through sound and its absence, what we are losing in the deaths of so many young people.

Among these examples of Margolles's more recent work, the trans women of Juárez command the greatest attention. They have all the attitude of Margolles's early self-portraits, and more. They are fabulous and tragic and mystifying in their survival. In 2010, the year of the worst violence in Juárez, Margolles grew increasingly worried about Karla. "The community of trans women and prostitutes were the last resistance," she told me. "All of the women had left. It was too dangerous. Most of the men had left. Those who stayed were drunkards." Karla made it through that time. There was a lull in the violence.

88 And then she was killed in 2015, her body discovered in an aban-
doned house near her own. Someone had bashed in her skull
with a rock.

As always, Margolles was working on a show at the time,
for the gallery in Zurich. She decided not to include Karla's full
color portrait in the *Pistas de baile* series. She created a shrine
for her instead, including the marquee of a nightclub installed
as a readymade, titled *Mundos*, 2016. For a later exhibition in
Austria, Margolles did the same with a mirror taken from
behind the bar of another nightclub, the RUV. In addition to
the names of the women, viewers of Margolles's work can men-
tally map out the venues shuttered in Juárez: the Mona Lisa, La
Cruda, Hollywood, and Madelón.

In Austria, Margolles installed another shrine to Karla,
hanging a black-and-white portrait on the wall of a darkened
room, painted a deep red, with a framed copy of Karla's death
certificate and a small speaker playing the testimony of another
trans woman reflecting on her colleague's death. A heavy
chunk broken off of a concrete brick, thought to be the murder
weapon, was placed under a spotlight on the floor before Kar-
la's portrait. Margolles invited another trans woman to partic-
ipate in a performance, which involved filling in a slash in the
wall. In an interview, the woman told her the performance felt
like applying ointment to a wound. "I find this very touching,"
Margolles replied, "this idea of healing, as if you were helping a
friend. It almost makes me cry."

Some of the trans women in Karla's circle had come to
Juárez from elsewhere in Mexico. Some had come from across
the border in Texas. Some had drug problems, others volatile
relationships. A few were arrested. Karla was the third to be

killed. Margolles's most substantial monograph to date, which
followed a major survey at a museum in Milan, is dedicated to
the three of them, with a line appealing to their imagination,
and to ours: "To Karla, 'La Gata,' Ivonne . . . and to all the women
who fight to resemble the idea that they dream of themselves."

Abounaddara

Part Three

A Life in the Shadows, Damascus

The story began with a gift. In the early 2000s, a young woman from Damascus named Maya Khoury received a beautiful piece of cloth as a present. The fabric was covered in an uncommon pattern of flowers. "I was so fascinated by its colors and its smell that I went to find the craftsman who had made it," Khoury recalled. She headed into the souks of the Old City to discover the shop where the clothmaker worked. "He was an old man who produced his own dyes and printed floral motifs on cotton fabrics, using wooden stamps according to an ancient technique."

At the time, Khoury was in her early thirties. She had studied literature at the University of Damascus and philosophy at the University of Vienna. She had no real connection to the worlds of art or film. But something about the clothmaker compelled her to record him, so she borrowed a camera and started filming his daily life.

Khoury found the clothmaker holding forth one day in his impossibly small shop, filled with huge wooden barrels of dye, hand-printed fabrics piled high onto hooks and laundry lines,

92 and a crowd of customers, mostly women, steadily nudging their way into the crammed space to barter and talk and joust with an artisan they had seemingly known for decades. Another day, Khoury found him working alone, rueful, listening to the news on the radio, and responding to what he was hearing in a language of gestures and tics that conveyed a wealth of running commentary without him uttering a word.

Khoury spent three months immersed in the clothmaker's world. Charismatic, mustachioed, with a shock of thick white hair and jack-in-the-box-style movements, he *was* a compelling subject, easy to image as the protagonist of an illuminating film, maybe a documentary emphasizing craft-based economies or a cinematic essay on the intimacies of everyday life in the Old City. He had an irrepressible sense of humor. He played on words as he went through the quick and deliberate motions of stamping ink flowers onto bolts of dyed floral fabrics, doubling their patterns and giving depth to their surfaces. His shop was a repository not only for cloths and motifs but also for stories, legends, current events, and memories. And, as it turns out, the work itself was historically significant.

When Syria won independence from France in 1946, it was this same clothmaker who printed the first flags of the young republic. That flag consisted of three horizontal bands of green, white, and black, with three red stars stamped side by side in the central white stripe. Syria has adopted nine different flags since 1918, reflecting a pattern of coups, insurgencies, and instabilities in the period following the end of the Ottoman Empire's rule. The current Syrian flag, also known as the regime flag, features two green stars on a white background between bands of red and black. It is the same flag that was used when Syria joined

Egypt to form the United Arab Republic in 1958, a brief, misguided marriage that broke apart in three years. That flag was retired, then reintroduced in 1980. These days, both flags are in use, depending on where you look, with the independence flag signaling affiliation with the opposition, the regime flag showing loyalty to Bashar al-Assad, Syria's current president.

The textile trade in Damascus is as old as the Silk Road, with elaborate and everyday fabrics moving from place to place, carried along through different cultures and various currencies, for thousands of years. The souks in particular, laid out along a Roman-era axis, are famous for *aghabani*, fabrics hand-printed and embroidered with silk thread on cotton or linen, typically used as tablecloths or bed coverings. In the months Khoury spent in his shop, the clothmaker was still working with cotton, which, in a sea of manufactured and mass-produced synthetics, was increasingly rare. In the years before the Syrian uprising of 2011, he was said to have been the last artisan of his kind in Damascus.

Khoury shot dozens of hours of what she believed was good, usable footage in his shop. She showed her material to a cinematographer she knew and was encouraged by the feedback she received. She began contacting producers. And she decided this was it, a way forward. She had discovered her medium. She wanted to make films. Her dream was cinema. It was powerful and liberating and daunting and potentially dangerous and it was never an idea that belonged to her or her imagination alone. It was a dream that she shared.

To look back on the Middle East from nearly any vantage point after the wreckage of the so-called Arab Spring, it can seem totally inconceivable that there were signs of optimism in

94 the region as recently as twenty years ago. All sense of histor-
ical perspective was bent out of shape by the eruption of spon-
taneous protests in Syria, which took virtually everyone by
surprise in 2011, and then even more so when the initial demo-
cratic spirit of the Syrian revolution was crushed by the regime
and turned into a fractious and brutal civil war, killing some
five hundred thousand people, displacing millions, setting off
one of the worst refugee crises in history, and acquainting the
wider world with staggering new forms of violence, torture,
and war crimes.

But at various points in the early 2000s, the political sit-
uation looked almost promising in certain parts of the Arab
world. The long-festering civil war in Lebanon had come to
an end. The peace process set in motion by the Oslo Accords
hadn't yet broken down, and the prospect of a lasting settle-
ment between Israelis and Palestinians seemed plausible, or at
the very least available to be used as a tool for addressing other
problems in the region. In 2000, within the space of two weeks,
two remarkable events occurred, one right after the other. First
and without warning, Israel abruptly withdrew its forces from
South Lebanon after eighteen years of occupation. Then Hafez
al-Assad, Syria's long-standing Baathist president, who had by
that point ruled the country with brutal, repressive, and insidi-
ously far-reaching efficiency for three decades—most famously
by means of torture, but also by dividing the intelligence and
security services into multiple and competing agencies to
render the state effectively coup-proof—suddenly dropped
dead of a heart attack.

Assad had wanted his brother Rifaat to succeed him. But
when Rifaat tried to stage a coup, Hafez sent him into exile and

chose his son Bassel instead. When Bassel was killed in a car crash, in 1994, the role of successor fell to his brother Bashar, a young man working as an ophthalmologist in London who was by all outward appearances decidedly unfit for the job. Bassel had been an elite athlete and a ruthless soldier. Bashar was an awkwardly tall and lanky man with a tiny head and a weak chin who spoke with a lisp. He was rushed back to Syria at the age of twenty-eight and raced through his military and political training. He became president at thirty-four. Given the tumult of that moment and the fact that Bashar had been more exposed to the world than anyone else in his family, there was initially some hope that he might loosen the grip of the Baath party and open up the country to democratic reforms.

And the first few months of Assad's presidency bore that out. Activists, opposition figures, and reform-minded members of the intelligentsia began to meet, informally at first, in private homes, and soon after in a series of more formal salons and public forums organized around the idea of changing the terms of Syria's political life. People responded to a moment of potential for political change with collective action, entailing an incredible and generative process of gathering and thinking and hammering out new concepts of freedom, development, and prosperity. Within months, there was talk of a full-blown Damascus Spring. A flurry of petitions, statements, and declarations were published and circulated around the region, signed by poets such as Adonis, novelist Abdelrahman Munif, and opposition figures like Michel Kilo and Anwar al-Bunni, alongside many other writers, professors, lawyers, playwrights, theater directors, cinematographers, journalists, researchers, and more.

96 Assad made some gestures in the direction of reform. He released hundreds of political detainees and closed the infamous Mezzeh prison in Damascus. Poet Faraj Bayraqdar, who had been arrested as a suspected communist in 1987, was released as part of a presidential amnesty. He immediately left the country. A few years later, another former prisoner, renegade painter Youssef Abdelke, who had fled Syria for a twelve-year exile in France, was encouraged by the Damascus Spring to return and resume his former life in the Old City. A number of important civil society organizations were established and allowed to survive. In a previously closed economy, global organizations—including media outlets, nonprofits, aid groups, music companies, advertising agencies, production houses for film and television, even international banks—were likewise allowed to enter Syria and operate there.

Then, in 2005, two more remarkable things happened. Lebanon's former prime minister Rafik Hariri was killed in a massive car bomb explosion in Beirut, and Syria, widely blamed for his assassination, was forced to pull its troops out of that country. Those events exposed some of the doublespeak characteristic of that time. Assad continued to imprison intellectuals and opposition figures and to torture them. His reforms had only ever really been economic, not political. "He framed this as a continuation of his father's trajectory toward a competitive market economy," noted Robin Yassin-Kassab and Leila al-Shami in their book, *Burning Country: Syria in Revolution and War*. "He rejected 'Western' democracy as an inappropriate model, in favor of Syria's own type of 'Democratic' thinking." According to Yassin al-Hajj Saleh, a dissident and

former political prisoner widely credited as the godfather of the
revolution to come, slogans such as "development and modern-
ization," like "stability and continuity," were put forth explicitly
to sidestep the reforms that opposition figures were demanding
at the time.

What followed was a bifurcated system of development,
occasional opening, and the veneer of reform on the surface
masking the old brutal realities underneath. Below the surface,
the regime hardened its positions, fortified its power, and mem-
bers of Assad's inner circle amassed tremendous wealth in this
period, in part through the awarding of lucrative contracts. The
first lady, Asma al-Assad, became a prominent arts patron and
was actively positioning Damascus to become a global capital
of culture, with world-class museums, festivals, and heritage
sites. All the telltale signs of late capitalist consumption were
flooding into the country—high-street shops for recogniz-
able global brands, outrageously expensive designer boutiques,
sleek new cafés and restaurants nestled into restored heritage
buildings, rising rents and gentrification, a fancy new Four Sea-
sons Hotel, commercial galleries selling art according to market
prices that held steady from New York to Hong Kong via Dubai.

At the same time, in the wider region, an outpouring of gen-
uine artistic, intellectual, and cultural activity created a critical
mass of nimble, self-organized institutions popping up in cities
such as Damascus, Aleppo, Beirut, Cairo, Alexandria, Amman,
and Ramallah. In this post-1989, post-Schengen, post-9/11
period, funding from organizations ranging from the European
Union to the Ford Foundation was abundant and often regional
in scope. Grants were extended to initiatives in the Arab world

98 to encourage networking, capacity building, and exchange among artists, cultural workers, and arts professionals in different countries. The vestiges of Arab nationalism and access to the internet made it possible for different art scenes to learn from and collaborate with one another. Added to that were the movements back and forth of young creative people who had been able to study abroad, return with ideas, start something new, and forge unexpected relationships back home through their work.

In 1993, the fabled Atassi Gallery, established in Homs in the 1980s, moved to the Rawda neighborhood of Damascus, where it performed the multifaceted roles of a full-fledged, critical-minded, nonprofit cultural center—organizing symposia, staging experimental performances, and publishing books alongside a proper exhibition program. In 1996, photographer Issa Touma opened an important gallery in Aleppo, called Le Pont, which then grew into an international festival. In the artistic ecosystem of the times, those particular initiatives were independent of the Syrian state and the ruling Baath party apparatus.

That is not to say that people were completely free. "Cultural entrepreneurs established arts organizations and initiatives that politically profited the regime," wrote Shayna Silverstein in a fascinating study on the shifting positions of Syrian dance in those days. Arts projects were tied to tourism and real-estate development and so there was real money at stake. Some of the world's major museums were happy to turn a blind eye to the regime's authoritarianism while scouting out new sources of funding for their own programs in New York, London, or Paris. For those who genuinely cared about the situation on the

ground, the risks were negotiable. "In Damascus," wrote the scholar Miriam Cooke in *Dissident Syria: Making Oppositional Arts Official*, "politically daring statements could be made in many different ways so long as the veil of abstraction or allegory remained firmly in place." But such statements were made, and audiences knew how to read them.

Maya Khoury's decision to pursue a career in film was totally in keeping with the dreams of that era. She knew exactly what she wanted to do. She wanted to make a documentary about her clothmaker. But she was stubborn about it. She didn't want to work with just anyone, under any circumstances, and she didn't want to compromise her vision. The era was hopeful but also misleading. She found the opportunities available to her in the 2000s both limited and infuriating. Basically, her options were divided in two.

She could work with the National Film Organization, an institution housed within the Ministry of Culture, which was set up at the time of the Baathist coup, in 1963, to centralize the production and distribution of films in Syria, bring talented filmmakers back from abroad, and apply their efforts to the Baath party's ideological line. But that would mean effectively burying her film in the bureaucratic quagmire of a cruel and censorious state. The National Film Organization released at best one or two films a year. She would have no guarantee that her film would ever be made or cleared to reach an audience of more than a very small number of people.

Or she could work with an international producer, one of the pan-Arab media companies operating out of the Gulf, for example, or a European television network such as ARTE. But there she faced the possibility of her film being deformed by

foreign bias or worse, reconfigured to fit the assumed narratives about what life in Syria was supposed to be like. She didn't want to be put in the position of reinforcing, rather than defusing, preexisting clichés about the oppression of women, ancient ethnic hatreds, the inscrutable East, or, as her colleagues would later put it, "to conform with what the honest citizen was supposed to know about the 'Complicated Orient,' the confrontation with Israel, political Islam, Eastern Christians, or apricots and pistachios."

"I ended up getting depressed after months of unsuccessful contacts with producers, who invited me to reduce my project to a sort of exotic reportage or even to stage myself as a woman to match the expectations of the pan-Arab or western television chains," Khoury said, in one of the only interviews she's ever given under her own name, with the women's supplement of the Italian newspaper *Corriere della Sera*. She decided not to work with any of them. Her documentary about the clothmaker was never made as such. But in the process of trying and failing to find a producer, Khoury met a number of other aspiring filmmakers who were as disenchanted as she was.

They decided to form a collective for gathering different filmmakers together and an independent production house with a respected cinematographer, George Lutfi al-Khoury, who had worked on a handful of important Syrian films. They put a dozen of their films online but kept them extremely short. Most of them were less than five minutes long. This served a conceptual purpose, but it also addressed a practical issue. If the authorities ever came after them for failing to submit their work to the censorship board—all films in Syria were required to have a censorship license—they could say their films were

trailers for as-yet-unrealized projects, posted online to attract potential investors. And then they decided to remove their names from everything they did and maintain total anonymity as a group.

"It was a game at the time," Khoury recalled. "None of us had studied cinema, we could not claim any filmography: we were professionally 'illegitimate.' We therefore created a virtue of need, invoking an alternative and mysterious legitimacy that perfectly suited our objective: to invite the public to ignore the identity of the author of a film in order to escape possible social or political representations."

Those early efforts from Khoury and her colleagues—dated 2010, in Arabic with English and French subtitles—were indeed as forward-facing as typical film trailers, suggestive of the many different things they could have become. *The Extras' Starlette* introduces an exhausted costume designer named Khouloud who is swarmed with extras on the set of a period film or television series, tasked with dressing dozens of men, women, and children for a scene in which a train passes by a crowd full of people. She turns to the camera at one point and says, with mock petulance: "Maya! Turn off your camera and come help me!" *The Smiters for Damascus* is set to a rousing piece of music by the Palestinian brothers Le Trio Joubran, and begins with a close-up of a man's hand etching a pattern in brass with a small hammer and pointed tool. Eventually, the camera pulls back to reveal a fuller workshop of several young men, muscled, tattooed, all hammering away on a large piece of multi-paneled brass.

In *The Inheritors of Discord*, a young man returns to a music shop where he purchased a CD of Syrian singer George Wassouf

102 performing a live version of an old song by Egyptian songstress
Um Kulthoum, beloved throughout the Middle East as the voice
of Arab nationalism. He complains to the shopkeepers that
Wassouf's voice sounds strange on one track, and they listen
together. The problem, the shopkeepers tell him, is the singer,
not the CD. "The problem is he's drunk!" one of them exclaims.
(Wassouf is famous for his excessive lifestyle, and his support
for Bashar al-Assad.) The elder shopkeeper explains that you
cannot compare Wassouf to the great singers of the past, who
"held their art to the highest standards, and their listeners were
also of a very high class." The young man doesn't care, and wants
to exchange it for a better recording. The shopkeeper refuses
and the young man leaves incensed.

The close attention to the rhythms of everyday life in these
films captures a wealth of telling details: habits of speech; ref-
erences to class, ritual, and myth; allusions to perceptions of
reality and the workings of belief. None of the films are apo-
litical. They mark out all of the major issues of the day, from
economic liberalization and privatization to kleptocracy, delu-
sion, and ruin. They are deeply enmeshed in society. But they
allow politics to filter through lived experiences, through ways
of storytelling and resorting to humor. The subjects of these
short films are all artisans of some kind. They cling to the dig-
nity of their work, their labor, the value of what they make and
fix and share.

The first, or perhaps the last, of these short films cen-
ters on Khoury's beloved clothmaker. In *The Stamp Man's Last
Stand*, we see him in his shop happily mixing his dyes, stamping
his flowers, chuckling to himself as he works. Then a group of
women press into the shop. As he carefully wraps their order

in newspaper, one of the women asks him, half-jokingly, for a discount. After all, she is a widow. He laughs. So is he! Then she suggests that he marry her mother, who has just buried her second husband. "Thanks, but I don't want a man-eater!" he exclaims. The women continue to tease the clothmaker, and he needles them back. But he won't budge on the price, or his freedom. Eventually the women leave in good spirits. The film ends on the man's hearty laughter.

Bullet Films

When Abounaddara first gained a following in the immediate aftermath of the Syrian uprising, it seemed to have come out of nowhere. Remarkably, the project appeared fully formed, in April 2011, with strict rules for how it produced and delivered its work, parameters for how it communicated with the world, and an elaborate intellectual scaffolding of ideas and concepts to support the films it made and the ethical vision of its members. That vision reached from the core of the Syrian conflict to the practice of journalism, the history of photography and film, and the legal conception of rights in relation to images as a matter of privacy, property, and dignity.

A collective of anonymous self-taught filmmakers, Abounaddara posted a short video every Friday on the platforms Vimeo, Facebook, and Twitter, with the release of each new film tied to the same schedule as the Friday protests that had erupted across Syria. All the videos were parked online and left there, free to watch for anyone who had a decent internet connection. The members of the group, who were said to be living and working in

Syria, were never identified by name. Only a spokesman, Charif
Kiwan, a political scientist based in Paris, carried the privilege
(or burden) of introducing the work in public, presenting man-
ifestos, giving interviews to journalists and academics, and
fielding questions in various symposia, conferences, and forums.

Automatically ordered into a chronological grid on the
group's Vimeo page, Abounaddara's videos were no more than
a few minutes long each. Some were a pastiche of modified or
previously existing material. In *The End*, 2011, a curtain obvi-
ously added to the original image slowly closes on a social
realist painting of Hafez al-Assad in an opulent government
building. In the virtuosic *Kill Them*, 2015, footage of conserva-
tive Fox News host Jeanine Piro (of Lebanese descent) fulmi-
nating against Arabs, Muslims, and the Middle East is edited
into the aggressive, jump-cut style of a driving music video.

Other videos created a powerful disjuncture between sound
and image, such as *Vanguards*, 2011, showing a class of school-
children barking out Baath party slogans, until a young girl casts
a sidelong glance, and we hear the clearly non-diegetic and now
spine-tingling protest chants of *"Hurriya! Hurriya!"* (Freedom!
Freedom!) that had echoed across Syria at the start of the rev-
olution. *Under Damascus' Sky*, 2011, presents a static shot of
the cityscape, dense and majestic in low light as the sounds of
crowds demonstrating rise in volume.

Many of Abounaddara's videos were funny, such as *Askar
ala meen?* (Military on Whom?), 2011, showing a remote-
controlled toy soldier crawling along a sidewalk to the sounds
of patriotic music. Others were devastating. A child narrates his
family's exodus from Syria. Another describes the bombing of
a bread line, an attack that's known as the "bakery massacre."

Another lies stoically on his stomach as a doctor stitches up a serious wound on his back. Two young men pull an old sewing machine from the rubble of a bombed-out building. A charismatic teacher offers beauty lessons for girls in a shelter with unreliable electricity. "Because war or no war, we're following fashion, right?" she says.

In *We Are Palmyra*, 2015, a man who had been jailed in Tadmor prison, infamous for the regime's cruelty and then blown up by the Islamic State, describes how the water had been salty there, and how, after his mother had washed his clothes for him all his life, he had needed someone to teach him how to do his own laundry. Presented without any situating details, his story is spare, delicate, and incredibly powerful. In *A Dream's End*, 2016, a former pilot, his face totally obscured and silhouetted against a window behind him, relates how he fainted while crossing a checkpoint when he was stopped and asked for his papers, one small anecdote from a long and complicated journey that eventually brought him to Germany. "It was a tribulation worthy of five years of revolution," he says.

Several of Abounaddara's films played with the visual language of authoritarian state propaganda, or with the bombastic style of Hollywood blockbuster film trailers. Or they developed an exasperated critique of the media, which thrived on bad news from Syria, massacres committed, cease-fires broken, but never did anything to stop them from happening. The videos could be cynical, sarcastic, and whimsical. They showed a penchant for literary titles and pop cultural references, alluding to a song by Bob Marley, the novels of Gabriel Garcia Marquez and Naguib Mahfouz, and a famous play by Syrian dramatist Saadallah Wannous, *An Evening's Entertainment for the Fifth of June.*

As the short films were released week after week, they began
to add up to a substantial and unprecedented body of work. They
also started to mark the passage of time and to create a ready-
made archive of the events unfolding in Syria. They captured
the thoughts and experiences of protesters, fighters, regime
loyalists, intellectuals, snipers, many teachers, and bystanders
who wrestled with whether or not to engage in what was going
on. The videos included appeals to the international commu-
nity, both sincere and embittered, to do something, anything, to
help the Syrian people survive their ordeal and live their com-
plex, multifaceted lives in dignity. They tracked changes in the
protest movement, the rise of groups like ISIS, the crossing of
red lines, decisions by world leaders, elections in Syria and else-
where, even the World Cup. In *Waiting for Messi*, 2012, scenes of
ardent football fans, their faces fixed in concentration, break for
a set of intertitles reading: "Messi supports the Syrian revolu-
tion. Do you?"

In some of the videos, there was no talking at all, only text
on-screen. Or they showed what appeared to be totally ordi-
nary and mundane scenes from everyday life, such as a taxi
driver getting lost and then finding the address he's looking for.
But the majority of Abounaddara's work dealt with speech—
testimonies, confessions, reflections, memories, anecdotes,
digressions, diversions, and the speakers struggling to under-
stand or make sense of the things they had seen. Their mono-
logues were delivered through a tremendous range of emotions.

The people in Abounaddara's films often spoke compul-
sively. Whole portions of the archive are devoted to individuals
who appear in multiple, sequential parts, such as a fighter with
the Free Syrian Army, the subject of *The Unknown Soldier, Parts*

108 *One, Two, Three, and Four*, 2012, who talks his way into a confession: he killed a man by slitting his throat and he can't explain why he did it. Other subjects were reluctant to speak at all. In *After the Image*, 2013, a man in extreme close-up addresses his connection to a video broadcast on Al-Jazeera of a mass killing. "Nineteen people executed at a checkpoint," he says wearily. But the film never divulges why his mother called him to tell him about this video, or who the man saw in the crowd and recognized as he watched it a second time. His face is heavy with anguish, but he speaks elliptically of the difficult choice between running away or facing the past. "The closer you get to death," he says, "the further it is from you."

One of the most bracing and effective works in Abounaddara's collection of more than four hundred short films made between 2011 and 2017 is *What Justice*, 2014. The film begins with an intense young man, sitting before the camera at a low table, with a drink in front of him. He is silent for nearly a minute before he suddenly shakes his head as if ridding himself of a haunting thought. "He has to die," he declares. "It's not about revenge. He has interrogated thousands besides me. But he's not human. He's something else. Something ugly. He is ugly." The man never says who he's talking about or what that person did to him. But he struggles mightily with the idea that real justice would only occur with an act that no one is willing to carry out. The film ends with him saying, just as abruptly as before: "You've uncovered the monster inside me. Happy now?" Then he gets up and walks away.

The force and brevity of Abounaddara's films came encapsulated in two key concepts: bullet films and emergency cinema. "When the revolution began, we tried to find a way to translate

this breakdown or explosion of energy," said Charif Kiwan, the group's spokesman, during a 2014 discussion in Beirut. "We wanted to translate this event formally. We wanted to create films like bullets. We wanted to make something beautiful and violent. We wanted to surprise the viewer. Maybe he is looking for information about Syria or looking for stereotypical images of militants or people. It was our first attempt to build a new format, so the importance of the editing here is huge because the idea here is to mix a present and a past, images from the past and sound from the present."

Emergency cinema was not, as was often assumed, a reaction only to the crisis that the revolution—and the regime's staggering crackdown in response to it—had ripped open in all aspects of Syrian life. It predated the uprising and was defined as much by the conditions that came before and a broader, longer lineage of art, literature, and philosophy grappling with oppressive politics. "People have misunderstood our use of the term," Kiwan told the writer Moustafa Bayoumi in a 2015 interview for *The Nation*.

Of course, we are in a state of emergency. This is a revolution that has turned into a war. But our notion of emergency was based on Walter Benjamin's idea that "the tradition of the oppressed teaches us that the 'emergency situation' in which we live is the rule." Our notion of emergency was based on disturbing and inventing: disturbing the machine that maintains the rules of the emergency situation, especially the rules of the film and media industries, and inventing new rules of representation.

Kiwan insisted that their fight was always over those rules of representation, even more so than it was against the regime. "As filmmakers, our primary concern is image. How to produce images. How to change representation with our images. Our priority is not to criticize the regime," he stressed. "We address our people with our images to prove to them that their experiences and their dignity matter. This is why our names don't appear on film. There is no voiceover. We are invisible. We are anonymous. We let our images speak." One of the most dramatic things about watching Abounaddara's work was the ways in which all sense of context and circumstance, all identifying details, had been drained from the videos, forcing viewers to read the images themselves much more closely for clues, for anchors, for grounds of interpretation. "The idea is always to collapse things," Kiwan said in Beirut, "to let the image tell more than you are seeing."

Something often lost in the critical reception to Abounaddara's work is how feminist the project, as a whole and in the details, appears to be. In *The Islamic State for Dummies, Part One*, 2013, a filmmaker standing somewhere off-screen bursts out laughing when a young man in military fatigues, looking like a small boy behind an oversized desk with satin curtains behind him and a nice fish tank beside him, starts talking in utmost sincerity about the creation of an Islamic State. Her laughter pierces through everything and is one of the most memorable moments in Abounaddara's oeuvre. In *Citizen of the Shadow, Part One*, 2013, a woman describes being chosen to march in a military parade when she was young. She had to train for it. But when the day of the march came, she refused to go. As a result,

she was held back a grade at school. Looking back on her own
defiance, she, too, laughs out loud.

There are many Abounaddara videos focused on women
and children. There are stories of mothers who sacrifice them-
selves and young women who break with their families or refuse
to let events dictate their lives. There are classrooms brimming
with affection and others foreboding more violence to come.
None of the characters in these films play to type or conform
to clichés. In *Confession of a Woman, Parts One and Two*, 2014,
a middle-aged woman sitting in the low light of a rented apart-
ment reflects on the meaning and nuance of beauty, age, and love,
and then delves into the "doom" of sectarian identity before and
after 2011. In *The Woman in Pants*, 2013, a former schoolteacher
describes her one-woman protest against the Islamic State. She
tells of fellow citizens who encourage her in private but are too
afraid to join her in public. She excoriates the distortions of
religion and the indoctrination of young people and laughs at
the fact that her clothing so offends the largely foreign fighters
who hide behind masks as they commit real crimes. "How can
the pants be sinful and not the mask?" she says.

In the multi-part series titled *Marcell*, 2014, a young woman,
sitting in bed, unleashing a torrent of words, and describing
herself as "a girl of the revolution," addresses complex notions
of privilege, responsibility, and class. She unpacks the absurdity
of being ordered around by militiamen who have only recently
joined the fight she has been a part of from the beginning, losing
friends along the way, carrying the weights of the dreams they
shared. She talks about difference and acceptance, the grocer
versus the soldier. She conveys her total willingness to veil in

a modest area out of respect for the society there but insists on her absolute refusal to do so at the command of militias. "No, I will not yield," she says.

Marcell speaks of losing her mother, of making her way in the world alone, of missing the protection that her mother gave her, shielding her from the judgments and insults of more traditional or sectarian neighbors. She speaks of wanting to hate the people who killed her mother, of struggling to see them as human, of her desire to be happy and not hate the world. "Hatred is paralyzing," she says. Most striking of all, she speaks of rising through the ranks of the revolution and acquiring the power to exact revenge, but then setting it all aside. "I don't want to possess such power," she says. Her interview is punctuated by the sounds of shooting outside. Marcell appears unfazed. Then, when she hears the sounds of protest, her face lights up. She stops mid-sentence, excuses herself, jumps up, and runs to see what's going on.

Kiwan once told an interviewer at Bard College that the majority of Abounaddara's members were women. Certainly, many of the films seem to enter realms that would be difficult for male filmmakers to access. More than that, the fragments of each video capture myriad and complex expressions of femininity and feminism under pressure. As viewers wading through the record of Abounaddara's work, we are constantly privy to a few moments in the lives of women who are serious and frivolous, resourceful and exhausted, fearless and dispirited, women who are teachers, lawyers, activists, and rebels, who are told by their mothers not to go "live like a slut in Beirut," or who look exactly like the pop star Haifa Wehbe and are maddeningly defiant in their support of Bashar al-Assad.

We are also ushered into the worlds of many charismatic, eccentric, but essentially unknowable characters, whose names we never learn, whose work we only glimpse. We meet journalists, teachers, and farmers. We catch glimpses of an ethnographic museum display, an elaborate war panorama, and bits of cinematic history. Abounaddara's first manifesto, titled "What Is to Be Done?" and issued on April 15, 2011, grounded the group's work in the marquetry of Jurji Bitar, who famously invented Damascene mother-of-pearl inlay in the 1860s by combining Christian and Islamic motifs and Arabizing Western cabinetmaking in the aftermath of anti-Christian riots and pogroms in Syria. Scroll all the way down Abounaddara's Vimeo feed to the very beginning and you find two videos featuring the clothmaker who so captivated Maya Khoury in the 2000s. *Infiltrators 1* pays a visit to the clothmaker's shop while he's listening to reports of protests on Syrian state radio. *Infiltrators 2* shows him riffling through different-sized wooden stamps, mixing his inks, and then stamping green stars onto the red, white, and black Syrian flag.

Within relatively small circles, it was never a tremendous secret that Abounaddara was the group that Maya Khoury had formed in Damascus when she decided to make films, wanted to do a documentary about the clothmaker, but found the options available to her undesirable and so banded together with others to create a new and different path. In an interview with the art historian Anneka Lenssen, the group, answering questions collectively, said: "The Abounaddara collective was practically born in the workshop of this Damascene artisan. . . . We all used to visit this place before we had even met each other, and we dreamed of cinema while contemplating the flowery cotton

114 fabrics spread out in the dark like so many petrified screens." But
 Khoury didn't associate herself publicly with the group until
 2017, when the artists' list for Documenta 14 was released and
 she was on it, as the author of a film produced by Abounaddara.

 The decision to give themselves a vernacular name—
 Abounaddara means "the man with glasses"—was always a way
 of insisting on their inextricable belonging to Syrian society
 as well as a means of inserting themselves into cinematic his-
 tory. "The man with glasses" alludes to Soviet director Dziga
 Vertov, whose experimental documentary *Man with a Movie
 Camera*, 1929, was also the inspiration for Jean-Luc Godard and
 Jean-Pierre Gorin, who in 1968 came together to make political
 films as the Dziga Vertov Group.

 Whether intentional or not, the name Abounaddara also
 referred to a nineteenth-century Egyptian satirical newspaper
 of nearly the same name. *Abou Naddara Zaqra*, meaning "the
 man in blue glasses," was named after the paper's founder, Yaqub
 Sanu, an Egyptian Jew of Italian origin, famously nearsighted,
 who took Abu Naddara for a pen name in his work as a journalist
 and playwright. Sanu's paper, which ridiculed the political fail-
 ures and ruinous economic policies of Khedival Egypt, was phe-
 nomenally successful in Cairo—"peasants crowded into coffee
 shops to hear it read aloud, and sheikhs were rumored to hide
 it in their turbans," noted writers Anna Della Subin and Hus-
 sein Omar—so much so that it was quickly banned and Sanu,
 fielding death threats and assassination attempts, was forced
 to leave Egypt for France. In Paris, he relaunched the paper and
 created an imaginary, fictional collective, made up of writers in
 different-colored glasses, who contributed to each issue. The
 foreign editions of *Abou Naddara*, which were smuggled into

Egypt, advocated for a dangerous revolution back home from the paradoxical safety of exile.

Some of the initial delicacy and whimsy of Abounaddara's work was obviously lost, perhaps justifiably so, in the shift from the time before the revolution to the era that followed the uprising morphing into civil war. As Kiwan said in his interview with writer Moustafa Bayoumi:

> We are all pacifists in Abounaddara. And we find it difficult to accept that the revolution was transformed into an armed conflict. But at the same time, we are not naive. We are making a revolution! We cannot change things without violence. I mean, pacifists are people who can control violence. Violence is everywhere. It's life. There is no life without violence. Love is violence. But our purpose is to control the violence, to exhibit it in a highly controlled way, in order to enchant life and keep death away.

When asked to describe their origins, Abounaddara often described their disillusionment with cinema as it existed in Syria. "At first, it was a group of friends from the same generation, barely getting by on the margins of Damascus' artistic or intellectual circles," they said in an interview.

> We stuck to trying to make films by the book, but it didn't work. Then, out of sheer stubbornness, we resorted to the internet at a time when the regime believed it was so powerful it could afford to give the little troublemakers from society a corner to agitate in. The idea was to use the web to swing the balance of power with the culture industry

in our favor, but without addressing politics head-on. In truth, making anti-regime films didn't really interest us.

In the 1960s, the National Film Organization had effectively killed off the local film industry in Syria—never robust but dating back to the 1930s—by forcing private studios and independent production houses to close. It also redefined the country's film culture, which had existed since 1908, when a café in Aleppo screened a film for the first time in public, followed by the opening eight years later of the first movie theater in Damascus (built on the site where the Syrian parliament stands now), which burned to the ground a month later.

The state-run system nevertheless produced a number of exceptional films. *The Lorry Driver* (1967), by Poçko Poçkovic, a Yugoslav director who had been brought over by the Syrian government to train a new generation of filmmakers, tells of the struggles of a poor truck driver abused by his bosses (George Lutfi al-Khoury, Abounaddara's first partner in the pre-2011 production house, was Poçkovic's cinematographer). Nabil Maleh's *The Leopard* (1972), which won first prize at the Locarno film festival, is based on a novel by the Syrian writer Haydar Haydar, about a peasant rebellion, too soon for its time, that is crushed by wealthy and corrupt landowners. And Tawfik Saleh's masterful adaptation of the Palestinian writer Ghassan Kanafani's novella *Men in the Sun* (1962) chronicles the fate of three Palestinian refugees who are smuggled across the Iraqi border to Kuwait, and betrayed. On the other side of the tremendous Arab defeat in the Six Day War, Saleh renamed the story *The Dupes* (1972).

By the early 2000s, a tightly knit, multigenerational group of Syrian filmmakers had come together through their work with, against, and sometimes in subversion of the National Film Organization. They included Ossama Mohammed, the youngest among them; Omar Amiralay, the only one committed exclusively to documentaries; and Mohammad Malas, who had made a number of historically important films including *Dreams of the City* (1983), about a boy coming of age in the Golan Heights in the 1950s; *Chiaroscuro* (1990), a documentary about an elderly, artisanal film projectionist (he made all of his own equipment) named Nazih Shahbandar, which was banned by the Syrian authorities; *Moudarres* (1996), a documentary about the modernist Syrian painter Fateh Moudarres; and *The Night* (1992), a sequel (or prequel, rather) to *Dreams of the City*, which the regime also banned.

In 2003, Omar Amiralay made the incendiary documentary *A Flood in Baath Country*, which exposed the shortcomings of the Syrian regime and the deadening effects of its propaganda machine in education, civic participation, agricultural man-agement, and massive infrastructure projects. Amiralay had worked outside of the state system, with European producers. Not surprisingly, his film was banned in Syria. Amiralay glee-fully took it to the country's resourceful community of intel-lectual property pirates, who put the film online, for free, in so many formats that it became ubiquitous. "It was a digital flood," he told writer Lawrence Wright. He paved the way for Aboun-addara's internet strategy.

Ossama Mohammed's second film, *Sanduq al-Dunya*, named for a traveling storyteller's old-fashioned picture box,

118 was selected to screen in the Cannes Film Festival in 2002, a triumph for Syrian cinema. The film portrays a large family living in an elaborate tree. A dying patriarch refuses to choose which of his three grandsons will take his name, setting off a bitter and exaggerated competition. *Sanduq al-Dunya* is a surrealist romp so extreme it makes David Lynch look conventional, which is all the more impressive for the critique of autocratic power (as well as the sidelining of women) that burns throughout the film. Mohammed's first feature, *Stars in Broad Daylight*, equally critical and bizarre, was also fêted at Cannes, in 1988; neither film was even shown officially in Syria.

The younger filmmakers included Ammar al-Beik, Meyar al-Roumi, and Joude Gourani. Nidal al-Dibs was somewhere in between, and among the last to study at the VGIK in Moscow. Rami Farah and Reem Ali took a documentary workshop with Amiralay in Amman. In Syria, their short films *Silence* (2007) and *Foam* (2006) were also banned. Some of them had come to cinema through visual art; some moved around and were often abroad. "They transit between Europe and Syria, relentlessly interrogating artistic and cultural expression in contemporary Syria, collective memory, the violence of the present regime, the overwhelming alienation of their generation, and the virtues of exile," wrote Rasha Salti, a writer and curator who organized a major survey of Syrian cinema in 2006. All of them worked on each other's projects, as camera operators, assistant directors, cinematographers, and screenwriters.

When I visited him in Paris in 2019, Ossama Mohammed told me they invented special credits to acknowledge their participation on one another's projects. He said he had played some small or large part in nearly every film produced by the National

Film Organization from his heyday until he left the country in 2011, for a government salary of $250 a month. He and his colleagues met every day to talk about their work and the state of their lives in the country. "We never spent one day not thinking about how to have a new Syria, a different Syria," Mohammed said. "This machine of secret police, this ruling mafia, the kingdom of corruption—we never spent one day not thinking about this."

A few years ago, Mohammed gave a talk in Dresden, where he described the strength he and his colleagues once had in numbers: "A lot of important Syrian films, very good cinema, very critical films, [were] made because of solidarity, solidarity between filmmakers. This gave us power," he said. But when I asked him about this, he likened that power to "freedom in a closed room." "I could walk in the street and feel that I was free," he explained. But the general public never saw their films, and among filmmakers "nobody had the inner force to face this machine of corruption alone. I needed all my strength and all what I don't know just to reach my own imagination. We knew we were working for the future. We didn't have to step back. But it was very difficult to have new names in cinema. We were in deep need of a new generation."

Abounaddara both was and was not a part of that new generation. In 2014, one of their short films, *Of God and Dogs*, a twelve-minute, one-shot interview with a Free Syrian Army soldier who confesses to killing an innocent man and seeks vengeance on the god who let him do it, won a grand jury prize at the Sundance Film Festival. That same year, the French-German network ARTE asked Abounaddara to produce a long-form edit of their weekly films to broadcast on European television. The

result was the fifty-two-minute film *Syria: Snapshots of History in the Making*, 2014, which was subsequently screened in events and festivals all over the world.

In 2015, Abounaddara won the prestigious Vera List Center Prize for Art and Politics. As a result, their work was celebrated, studied, and shared via a multi-panel symposium and exhibition in New York. The New Museum, also in New York, included a selection of the weekly videos in an expansive show about contemporary art in and from the Arab world. Okwui Enwezor invited Abounaddara to participate in the Fifty-sixth edition of the Venice Biennale. The curator Adam Szymczyk, artistic director of Documenta 14, commissioned the collective to make a new, feature-length film, to be premiered at the opening of the exhibition in 2017.

But with exposure came pressure, and Abounaddara soon began to balk. They had moved into the art world to achieve tactical goals. The concepts of bullet films and emergency cinema had coalesced into a sustained and multilayered attempt to create an actual legal framework for guaranteeing "the right to the image," to protect the Syrian people, among others, from being depicted in the media as a pitiful mass of bruised and mutilated bodies. The idea was that Americans and Europeans could reasonably demand and expect to be treated with dignity in the circulation of their images, the most famous example being the ban on showing pictures of US soldiers' coffins returning from foreign wars. The same consideration did not extend to whole populations of people. Abounaddara's campaign sought to level those hierarchies and eventually moved into the domain of privacy and property rights in relation to the history of photography and film.

But when Abounaddara had to negotiate their place in large group exhibitions, they often took offense. The terms of participation in the art world were never their interest. Despite winning a special mention from the jury, they noisily withdrew their work from the 2015 Venice Biennale, claiming that they had been censored. The curator Okwui Enwezor swiftly denied this and said their work had been shown in the exact conditions they asked for. They didn't submit the new film for Documenta in time for the opening in Athens. An edit of the weekly films was lined up to screen at the Museum of Anti-Dictatorial and Democratic Resistance, but according to the curatorial team, at the last minute, the museum's board, which was composed primarily of elder leftists from the Greek resistance, refused to allow Abounaddara's films to show there.

Abounaddara has declared many enemies over the years. During the Vera List Center's symposium, they evoked Hannah Arendt and said: "The enemy is indifference. The enemy is the banality of evil." To the film magazine *Variety*, they added: "Context is our enemy." It may be that the art world was their enemy, or the situation in Syria that made working together, or being contextualized in the same space, such a challenge. Or that it was always, like the revolution itself, a fight to be seen and treated with dignity. At the Vera List Center, Kiwan said:

> We refuse to reduce our people to victims. We don't want the viewer to pity them. We want just to represent our society accurately. . . . Help us change our image in your society. . . . We hate the artistic small world because it is not our world. I mean, we have the duty to stay with our people, in the midst of our society, to defend them

122 and to do something for them—if we want them to accept
 us. Now, again, it's not the time to think about film, art,
 but to change the world, to save the world. Our society
 is being totally destroyed. So, again, and I'm sorry I'm
 insisting on that, but it's my duty. I came here to say that.
 Take our films and use them as examples to show that it
 is possible. . . . Help us here and now or leave us in peace
 to pursue our failed revolution.

Dignity in Art and Life

In ten short years, the narrative momentum of the Arab Spring downshifted so dramatically from exhilarating to sad that it is sometimes difficult to remember how hopeful it once was. But in relation to the work of Abounaddara, it makes sense to revisit where it began. The initial public response to the self-immolation of Mohammed Bouazizi, who set himself on fire in the Tunisian city of Sidi Bouzid on December 17, 2010, and died in the hospital on January 4, 2011, was singular and clear. It was a call for dignity, *karama* in Arabic. That was the word that echoed across the region and reverberates today.

Bouazizi was twenty-six, extremely poor, and had been selling fruits and vegetables from a street vendor's cart for half his life. He was one of five children. His father, a construction worker in Libya, had died when he was three. He left school at twelve and was the breadwinner of his family. Bouazizi would buy produce at a wholesalers market and resell it. His work depended on an endless loop of debts and repayments.

124 He often fought with municipal inspectors who fined him or extracted bribes.

The day he set himself on fire, Bouazizi had gotten into an argument with an officer he knew, a woman, who allegedly slapped him in the face, spat on him, and cursed his father. Some said that her colleagues gave him a beating. The officer, Fadia Hamdy, denied the details, though not the central facts that she and Bouazizi fought, and that she took his crates of fruit and seized his electronic scale, an expensive piece of equipment. When Bouazizi turned up at Sidi Bouzid's public administration building to retrieve his scale, he was turned away. In front of the building, he doused himself in gasoline and set himself alight. Ten days after he died, in the face of mass protests ripping through the country, the Tunisian president, Zine al-Abidine Ben Ali, fled for safe haven in Saudi Arabia.

People who knew Bouazizi well and had never heard of him before both said that being slapped by a woman was an immediate shock and an affront to male pride. But at the same time they all said they were sure that what really drove Bouazizi to self-immolation was the weight of humiliation and arbitrary violence heaped onto a young man who was already financially desperate. People could relate to that, and soon they were demanding the fall of their regimes. In the months and years that followed, there were hundreds of copycat self-immolations around the world, including one in the northeast Syrian town of Hasakeh, which had been decimated by four years of drought.

On January 28, 2011, a young man named Hassan Ali Akleh set himself on fire in Hasakeh to protest the regime of Bashar al-Assad. According to Yassin-Kassab and Shami, this event, though tragic, passed largely unnoticed. A few small protests

expressing solidarity for Tunisia and Egypt were held in early
February and likewise gained little traction. But on February 17,
more than a thousand protesters gathered in the central Dama-
scene neighborhood of Hareeqa (Arabic for "fire"), named after
a French colonial bombardment in the 1920s. When a traffic
cop beat up the son of a local trader, protesters responded by
chanting, "The Syrian people won't be humiliated!"

But the incident that truly set the Syrian revolution in
motion was, according to scholar Lisa Wedeen and Dutch aca-
demic Reinoud Leenders, the arrest of two women, also in
January 2011, in the southern city of Daraa, after they were
overheard talking about the protests in Tunisia and Egypt
and speculating whether Syria was next. In March, a group
of fifteen children, including the women's own, were caught
scrawling anti-regime graffiti on the wall of their school, and
were arrested. Word began to circulate that the police were tor-
turing them. "When their parents went to plead with the local
head of political security, a cousin of the president called Atef
Najib, they were told: 'Forget your children. Go sleep with your
wives and make new ones, or send them to me and I'll do it.'"
This was another affront to male pride, which sent thousands of
protesters to the streets. Security forces fired live ammunition
and water cannons, killing at least four people.

When Assad addressed the nation for the first time after the
demonstrations began, instead of striking a conciliatory note, he
attributed the uprising to Islamic militants and foreign agents.
He also punctuated that first speech with creepy laughter. Pro-
tests spread to cities all over Syria, and the army responded by
killing a thousand civilians and arresting thousands more, emp-
tying the prisons of Islamists and criminals to make space for

126 demonstrators picked up from marches in the streets. Multiple and competing opposition groups formed. They organized, armed, and, as the journalist Charles Glass memorably phrased it, sold themselves to foreign sponsors, including Qatar, Saudi Arabia, Turkey, Russia, the United Kingdom, and the United States. Hezbollah in Lebanon, supported by Iran, joined in to support Assad. Kurdish groups carved out short-lived autonomous enclaves such as Rojava. Groups like ISIS and the Nusra Front emerged as perfect foils for the regime and mopped up media attention for years with gruesome and theatrical crimes. The world became intimately acquainted with the destruction of barrel bombs and pictures of dead children washing up on the shores of the Mediterranean, having fled the violence with their parents on flimsy, unseaworthy boats. Estimates put total deaths at more than half a million, with more than 150,000 civilians dead, over 6 million refugees, and over 6 million internally displaced.

In the spring of 2011, Ossama Mohammed was invited to the Cannes Film Festival to speak on a panel about the detention of the filmmaker Jafar Panahi in Iran. Mohammed, who admired Panahi's work, accepted. By the time he arrived in France, the situation in Syria had deteriorated so rapidly that he brought a petition with him, written in a rush and signed by more than a thousand people, calling on filmmakers around the world to demand an end to the Assad regime's killing and express solidarity with the Syrian people. Among the signatories were Jean-Luc Godard and Catherine Deneuve.

 The petition put Mohammed's life in danger if he were to return to Syria, so he stayed in France, where he made *Silvered*

Water: Syria Self-Portrait, 2014, in collaboration with Wiam
Semov Bedixan, a Kurdish schoolteacher who smuggled a
camera into the siege of Homs. Despite the beauty of their col-
laboration, *Silvered Water* was gruesome to watch, composed
almost entirely of YouTube footage: a boy tortured in a police
station, crowds of protesters sprayed with bullets, mutilated
bodies, bloodied streets, the bodies of dead children. It opens
with the lines: "This is a film made of 1,001 images / Shot by
1,001 Syrian men and women / And me." Mohammed narrates
the film like a confession, until Semov enters the plot, and their
exchange takes over. References abound to major historical films
responding to acts of violence, including Alain Resnais's *Hiro-
shima Mon Amour* and Jean-Luc Godard's *Notre Musique*. But
the response from other Syrian filmmakers was brutal. Many of
them denounced it, ending old friendships. "This is also what
war does," said Akram Zaatari, a Lebanese artist who was deeply
influenced by Syrian cinema and knew all of the filmmakers.

Soon, the spectrum of Syrian cinema was in open revolt.
Mohammad Ali Atassi, a major documentary filmmaker and
founder of another important collective, the production house
Bidayyat, articulated a trenchant critique of film, violence, and
dignity. Abounaddara weighed in and were attacked for acting
in bad faith, working in a manner contradictory to their ethics,
or being the makers of mere video-clips. In his introduction to
Dork Zabunyan's *The Insistence of Struggle*, one of the most sub-
stantial accounts of Abounaddara's work, writer Stefan Tar-
nowski, who had subtitled many of the weekly films, suggested
that the momentum for "the right to the image" grew out of a
public discussion with Atassi about Mohammed's film during a
documentary festival.

"The 2011 uprising had begun with peaceful protesters demanding reforms, but, as the government cracked down and rebel factions arose, the country entered a death spiral," wrote journalist Anand Gopal. "One Syrian town after another fell out of government control, and from this anarchy new horrors arose. . . . Syria was said to illustrate the folly of imagining, in a region riven by religion and ethnicity, that a better world was possible."

But that imagining had happened and was captured in an outpouring of artistic, cinematic, and performative work. The demand for dignity brought people to the street. But it was accompanied by a diversity of protest strategies, suggesting a wealth of creative potential that had long been suppressed.

"At a certain point absurdity became a strategy and pro-testers would just walk around wearing white," recalled New York—based curator Ruba Katrib, whose extended family remained in Syria well into the war. "Or have blank cards or put cassette tapes in radios and play lectures on democracy and leave them in public spaces. Or throw roses at soldiers. Protesters and activists and revolutionaries, or whatever you want to call them, were engaging in acts of absurdity because they were in a sce-nario that made no sense." One day, protesters added blood-red dye to the water filling many of the public fountains in Damas-cus's squares, gardens, and roundabouts. "Within hours, the army drained the fountains dry. The next morning, the Barada River that rings Damascus was entirely red." Another day, pro-testers took several hundred Ping-Pong balls to the top of Qasiyun Mountain, above the homes of Bashar al-Assad and his inner circle, and flung the balls down the mountain all at once. The sound was apparently deafening as they bounced and

tumbled, bounding through yards and fancy villas and quiet
streets. On each ball, the protesters had painted words or phrases
associated with the revolution, such as "Freedom!" and "Leave!"

In addition to the humor of the Friday protests—expressed
through signs, slogans, and the modified lyrics of well-known
chants—people danced. In a 2012 essay, Rasha Salti described
this as one of the most surprising features of the early uprising:

> Invariably, in freezing cold and excruciating heat, at night
> and during the day, and even in some funeral proces-
> sions, insurgents dance the *dabkeh*, a traditional folkdance
> common to the Levant celebration. In the case of funerals,
> the *dabkeh* is performed only when the deceased is young.
> Syrian insurgents perform a version of the *dabkeh* in which
> dancers stand side by side, their arms stretched on the
> shoulders of one another, forming a chain of solidarity and
> moving in synchrony. *Dabkeh* is not exclusive to men, nei-
> ther traditionally nor in the Syrian insurgency; in video
> recordings of protests in cities known to be very socially
> conservative, such as Aleppo, women visibly accompany
> their male counterparts.

> Dancing as an insurrectional practice has deeper impli-
> cations beyond this recentering of the body. Foremost is
> the choice to claim moral high ground using a pacifist, fes-
> tive, joyous, and life-affirming language. . . . For decades,
> the Arab world seemed doomed to a sense of ironfisted
> rule by despots and their offspring. . . . The revival of the
> body in the Arab insurgencies, as the crucible of a sui
> generis subjectivity, in spite of the body count, is the real
> beginning of restoring dignity to the living and the dead.

Conclusion

Abounaddara stopped releasing their weekly films in 2017. They never did complete a final cut of the feature film they were commissioned to make for Documenta in time for it to be shared with the event's public. A version was shown for a private audience before the end of the exhibition, which typically runs for a hundred days. A version was also screened by the Vera List Center in New York, as a follow-up to the symposium and exhibition it had devoted to Abounaddara's work in 2015. But, again, it was shown only for invited guests. A book that had been in the works for years, by all accounts complete, was never published.

Then, in the summer of 2019, Maya Khoury's feature *Fi al-thawra* (During Revolution), 2018, produced by Abounaddara and the Swedish documentary film initiative Noncitizen, premiered at the Locarno Film Festival.

The jury in Locarno gave *Fi al-thawra* a special mention in the first-feature category. The film was selected for the Doc Fortnight Festival at the Museum of Modern Art in New York, where it screened in February 2020, right as the COVID-19

pandemic was gaining ground. Unlike the weekly films, which were crystalline and precise, *Fi al-thawra* was more than two hours long and strangely formless. It was characteristic of Abounaddara's work in that all identifying names, details, and contexts were stripped away, forcing the viewer to struggle through footage of protests, boring work-related arguments in computer chatrooms, lovers' quarrels, NGO capacity-building sessions, and public forums where intellectuals prove themselves ridiculous. There are tires burning and children's bodies in the street. A handful of women periodically emerge as compelling characters, fighting for a revolution that is failing.

As writer Sadia Khatri noted for *Indie Wire*: "The result is a scattered narrative which is all over the place, which refuses to locate the viewer in time or space. Unless one personally recognizes the faces and markers in the film, it is impossible to say what city a scene occurs in, what positions various individuals hold in the political context, what an argument is really about, how much time has passed between each cut. . . . Instead, the scenes shift without explanation or connection, and just when you feel yourself developing conclusions, it changes again."

Khatri ultimately concluded that *Fi al-thawra* worked in its own strange way by opening itself up to comparison with other contexts, by refusing to be pigeonholed. During the public discussion after the screening in New York, I asked Charif Kiwan, who was there in the usual role of spokesman, about the potential feminism of the film, and he said that Abounaddara hated the cliché of the oppressed female filmmaker who escaped from Syria to tell the world of its sorrows. "We hate the idea of the filmmaker coming, oh, she got out, she's a woman," he said. Since 2017, Abounaddara had made a book, in Arabic, about "the

right to the image." But they hadn't resumed the weekly films, and their feature had almost no hope of screening in Syria. "We are defeated," he said. "We are traumatized. We had the feeling and still have the feeling that we need to find a new way. We have to find another way."

By foregrounding the idea of the collective, Abounaddara had come up against the limits of working together and providing useful models for others looking for examples of collaborative practice. The group weathered the pandemic with a prestigious fellowship in Paris, made a twenty-minute film about the image of Donald Trump, and had many things to say about footage of the Capitol riots on January 6 compared to militants and protesters in other contexts.

Fi al-thawra included a cinematography and sound credit to Oussama al-Habali, who had been the subject of a handful of Abounaddara's films, including *Media Kill*, 2012, about the culpability of news outlets in perpetuating the Syrian crisis, and *We Who Are Here*, 2016, where he appears charismatic, goofy, and undaunted in a Beirut hospital bed after being shelled in Syria. He was the only other filmmaker previously named as a member of Abounaddara. He was arrested crossing the border from Lebanon into Syria in August 2012, and never seen again.

In Delhi, Amar Kanwar was the only artist on the jury for the 2022 edition of Documenta, which selected ruangrupa, an artists' collective in Indonesia, as the next artistic director. Ruangrupa, in turn, decided to devote their exhibition as a whole to the work of collectives worldwide. Kanwar also worked quietly with writer David Teh and curator Ute Meta Bauer on the next Istanbul Biennial, which they were organizing as a group.

Teresa Margolles, meanwhile, was chosen for one of the most prominent public art projects in the world, the Fourth Plinth in London's Trafalgar Square. Her proposal is to create an imposing sculptural work titled *Improntas* (Imprints), taking the "life masks," or facial casts, of 850 trans people from across the globe, including members of the Juárez community of sex workers who are the subjects of so much of her recent work, arranging them in the form of a Mesoamerican skull rack, or *tzompantli*.

Used by ancient civilizations to display the heads of slaughtered enemies, prisoners of war, or the victims of sacrifice, Margolles's "life masks" will comprise a four-sided cube with the insides of each mask facing out. They will appear on the plinth for two years, starting in 2024. Due to their material, everyday plaster, they are meant to deteriorate and disappear over time. For now, one is left to imagine some of the most vulnerable people in the world, from one of the most dangerous border towns on earth, being honored in the heart of London, one of the primary metropoles in the history of colonialism and global conflict, with a memorial of masks to honor their lives. It will be an occasion to reflect on the fact that art will have made it possible to see them there so clearly.

Nicholas Lemann, Jimmy So, Camille McDuffie, and Allie
Finkel are a wonderful team and I thank them for their patience,
encouragement, and feedback. I also thank artists Amar Kanwar,
Teresa Margolles, and the anonymous members of Aboun-
addara for the work they do and the generosity they extend to
those of us who are constantly asking them to explain it. This
book benefited from case studies I've worked on with students
at the American University of Beirut, the Académie Libanaise
des Beaux-Arts, and the School of Visual Arts in New York, as
well as a writing workshop at the Townhouse Gallery of Con-
temporary Art in Cairo. I'm grateful for the conversations and
debates that occurred in those classrooms.

Writing can be solitary work, but research and reporting
are decidedly social. Special thanks to everyone who helped me
in ways both big and small: Haig Aivazian, Christopher Allen,
Svetlana Alpers, Mohammad Ali Atassi, Sonja Mejcher Atassi,
Defne Ayas, Ghiath Ayoub, Negar Azimi, Rayya Badran, Shumon
Basar, Saeed al-Batal, Éric Baudelaire, Mohamad Bazzi, Banu
Cennetoglu, Jace Clayton, Robyn Creswell, Halle Darmstadt,
Fouad Elkoury, Mariam Elnozahy, Michèle Faguet, Simone
Fattal, Danielle Forest, Brad Fox, Yana Gaponenko, Natasha Gin-
wala, Marian Goodman, Rosa de Graaf, Charles Guarino, Mad-
eleine Haeringer, Lynda Hammes, Angela Harutyunyan, Nicola
Henderich, Sofía Hernández Chong Cuy, Jennifer Higgie, Yun-
sung Hong, Shanay Jhaveri, Ziad Kalthoum, Katia Kameli,
Daniel Kapp, Thierry Kehou, Bouchra Khalili, Kristine Khouri,
Peter Kilchmann, Marguerite Afi Sanyo "Gentille" Klugan, Carin
Kuoni, Glenn D. Lowry, Khaled Malas, Cuauhtémoc Medina,

136 Gema Melgar, Naeem Mohaiemen, Ossama Mohammed, Lina Mounzer, Leslie Nolen, John Oakes, Linda Pellegrini, Walid Raad, Yasmine El-Rashidi, Lindsay Sagnette, Rijin Sahakian, Yassin al-Hajj Saleh, Rasha Salti, Stacy Schermerhorn, Adam Shatz, Katy Siegel and all of the students and professors and staff in the Art History and Criticism Program at Stony Brook, Mari Spirito, Rania Stephan, David Levi Strauss, Beth Stryker, Stefan Tarnowski, Christine Tohme, Jalal Toufic, Michael Vazquez, David Velasco, Natalie Vichnevsky, William Wells, Madison Winkes-Cantrell, and Akram Zaatari.

For unyielding support, love, and good humor along the way, a personal set of thanks to the immediate and extended members of the Wilson-Goldie and Osseiran-Saidi families, to Noor and Amal, and to Ibrahim.

The full run of Abounaddara's four hundred-plus films, made between 2011 and 2017, are openly available for anyone with a decent internet connection to watch on Vimeo at this address: https://vimeo.com/user6924378. The group also maintains a Facebook page: https://www.facebook.com /abounaddarafilms and its members are active on Twitter: https://twitter .com/abounaddarafilm.

Stills and information about the work of Amar Kanwar can be found on the website of the Marian Goodman Gallery: https://www.mariangoodman .com/artists/48-amar-kanwar/.

To see details from the oeuvre of Teresa Margolles, visit the websites of the galleries James Cohan in New York: https://www.jamescohan.com/artists /teresa-margolles2 and Peter Kilchmann in Zurich: https://www.peter kilchmann.com/artists/teresa-margolles.

Laura Raicovich, former director of the Queens Museum, has written an excellent book, *Culture Strike: Art and Museums in an Age of Protest*, on the tensions, contradictions, and ethical dilemmas that have been ripping through major institutions in the art world of late. If readers are interested in a proper exposé on the increasingly outrageous financial stakes of the art market, Michael Shnayerson's *Boom: Mad Money, Mega Dealers, and the Rise of Contemporary Art* offers a sobering account, from the 1940s to the present. Fourteen years after its initial publication, Sarah Thornton's *Seven Days in the Art World* remains an enjoyable introduction to the circulatory nodes that move contemporary art around the world.

For further reading on the subject of art made in response to violence, I recommend T. J. Clark's *Picasso and Truth: From Cubism to Guernica*, John Elderfield's *Manet and the Execution of Maximillian*, Svetlana Alpers's *The Vexations of Art: Velázquez and Others*, Lawrence Weschler's *Vermeer in Bosnia: Selected Writings*, Susan Sontag's *Regarding the Pain of Others*, Susie Linfield's *The Cruel Radiance: Photography and Political Violence*, David Levi Strauss's *Between the Eyes: Essays on Photography and Politics*, Jane Kramer's *Whose Art Is It?* and virtually all of the writings of the late curator Okwui Enwezor, who insisted on the complexities of art in relation to contemporary politics and long histories of epochal violence.

138 On the work of Amar Kanwar and the subject of resource extraction in cen-
 tral and eastern India, I suggest two of Kanwar's own publications—*The
 Sovereign Forest* and *Evidence*—as well as Felix Padel and Samarendra Das's
 dense but revelatory *Out of This Earth: East India Adivasis and the Aluminium
 Cartel*, Arundhati Roy's *Capitalism: A Ghost Story*, Rana Dasgupta's *Capital:
 The Eruption of Delhi*, and, for a deeper history, the novels and stories of the
 Odia-language writer Gopinath Mohanty.

 On the work of Teresa Margolles and the history of the drug wars in Mexico,
 I recommend Margolles's *Ya Basta Hijos de Puta* (Enough Motherfuckers),
 Frontera (Border), *Mundos* (Worlds), *We Have a Common Thread*, and *What
 Else Could We Talk About?*; Roberto Bolaño's *2666*, which hurtles through a
 fictionalized history of femicide in Ciudad Juárez; Élmer Mendoza's Edgar
 "Lefty" Mendieta detective novels, set in Culiacán; Fernanda Melchor's
 Hurricane Season; investigative journalist Anabel Hernández's *Narcoland*;
 and Oscar J. Martinez's *Ciudad Juárez: Saga of a Legendary Border City*. Rubén
 Gallo's *New Tendencies in Mexican Art: The 1990s* and *The Mexico City Reader*
 contextualize Margolles's work in the scene(s) from which it emerged.

 Several recent publications address the work of Abounaddara through
 anthropology and media studies, such as Donatella Della Ratta's *Shooting
 a Revolution: Visual Media and Warfare in Syria*, Peter Snowden's *The People
 Are Not an Image: Vernacular Video After the Arab Spring*, Lisa Wedeen's
 Authoritarian Apprehensions: Ideology, Judgement, and Mourning in Syria,
 and Dork Zabunyan's *The Insistence of Struggle*. Abounaddara's book on
 the ideas, arguments, and potential legal frameworks for "The Right to the
 Image" is freely available online in Arabic, as are the group's periodically
 issued manifestos, such as "Dignity Has Never Been Photographed," "The
 Syrian Who Wanted a Revolution," and "We Are Not Artists."

 For in-depth reporting and analysis on the 2011 uprising and subse-
 quent civil war in Syria, I recommend Robin Yassin-Kassab and Leila
 Shami's *Burning Country: Syrians in Revolution and War*, Charles Glass's
 Syria Burning, Sam Dagher's *Assad or We Burn the Country: How One Fam-
 ily's Lust for Power Destroyed Syria*, and Yassin al-Hajj Saleh's *The Impos-
 sible Revolution: Making Sense of the Syrian Tragedy*. Rasha Salti's *Insights
 Into Syrian Cinema: Essays and Conversations with Contemporary Filmmakers*
 provides a wonderful and essential history, necessary for contextualizing
 image-making in the country, the region, and its multiple diasporas today.

NOTES

EPIGRAPH

11 **History is usually the sum of instances and expressions of violence:** In conversation with the author, Paris, February 24, 2019.

PREFACE

18 **"the last refuge of political and intellectual radicalism":** Cuauhtémoc Medina, "Contemp(t) orary: Eleven Theses," in *What Is Contemporary Art*, edited by Julieta Aranda, Brian Kuan Wood, and Anton Vidokle (Berlin: Sternberg Press, 2010), pp. 19–20.

INTRODUCTION

24 **"We move from one crisis to another":** "Lesson of the Crisis: Sir A. Chamberlain's Review of Events," *Yorkshire Post*, March 21, 1936, p. 11 (British Newspaper Archive).

24 **"how art functions in an era of lies":** Ralph Rugoff, "May You Live in Interesting Times," La Biennale di Venezia, Fifty-eighth International Art Exhibition, p. 1.

24 **"So, you really wanted to live in boring, stable, prosperous times":** Michael Kurcfeld, "The 58th Venice Biennale Exhibition: Meet Curator Ralph Rugoff," *Los* *Angeles Review of Books*, June 5, 2019, https://www.lareviewofbooks .org/av/58th-venice-biennale -exhibition-meet-curator-ralph -rugoff/.

25 **"one of the most memorable and frightening works ever shown there":** Moira Jeffrey, "Interview: Teresa Margolles, Artist," *The Scotsman*, April 17, 2012.

31 **"Artists are seldom brave, nor need they be":** T. J. Clark, *Picasso and Truth* (Princeton, NJ: Princeton University Press, 2013), p. 19.

CHAPTER ONE

34 **"the uncrowned king of 10,000-odd workers":** Modhumita Mojumdar, "The Sacrifice of Guha Niyogi," *Sunday Statesman*, October 13, 1991, p. 5.

36 **as possibly the worst that India has ever seen:** Felix Padel, "A Resource War to Die For: Is the Conflict over Minerals Centred in Chhattisgarh the Worst War There Has Ever Been in India?" *Journal of People's Studies*, Volume 2, Issue 1–4, July 2017, p. 39. See also Ilina Sen, *Inside Chhattisgarh: A Political Memoir* (Haryana: Penguin Books India, 2014).

36 **"Chhattisgarh has been a war zone for more than a decade":**

140 Amar Kanwar, "The Prediction," in *The Sovereign Forest*, edited by Daniela Zyman (Berlin: Sternberg Press, 2014), p. 250.

36 **"I made a film about standing in line":** Amar Kanwar, in conversation with the author, July 26, 2018.

CHAPTER TWO

41 **"a modern parable about two people's quiet engagement with truth":** Quoted on http://amarkanwar.com/such-a-morning-2017/.

42 **"Life was always out on the street and it was rough":** Amar Kanwar, in conversation with the author, July 26, 2018.

42 **"India seemed to be going up in flames":** Mark Tully and Satish Jacob, *Amritsar: Mrs. Gandhi's Last Battle* (New Delhi: Rupa Publications India, 1985), p. 5.

42 **"They'd seen their husbands and fathers burned alive":** Amar Kanwar, in conversation with the author, July 26, 2018.

46 **the Indian art world initially objected:** Zehra Jumabhoy, "Amar Kanwar," *Artforum*, February 2014, https://www.artforum.com/print/reviews/201402/amar-kanwar-45043.

CHAPTER THREE

48 **"I had never seen so many people":** Amar Kanwar, in conversation with the author, July 28, 2018.

49 **"the most inspiring political mass movement I had even seen":** Amar Kanwar, "Embracing Doubt," *Marg: A Magazine of the Arts*, Volume 70, Issue 1, September–December 2018, pp. 56–66.

49 **"not despite the boom in the Indian economy but because of it":** Rana Dasgupta, *Capital: The Eruption of Delhi* (New York: Penguin Books, 2015), p. 259.

49 **"Land was repossessed under an authoritarian law":** Rana Dasgupta, pp. 259–60.

52 **"If the flat-topped hills are destroyed, the forests that clothe them will be destroyed, too":** Arundhati Roy, "The Heart of India Is Under Attack," *The Guardian*, October 30, 2009, https://www.theguardian.com/commentisfree/2009/oct/30/mining-india-maoist-green-hunt.

52 **"taught filmmaking informally":** Ute Meta Bauer and Anca Rujoiu, "On *The Sovereign Forest*: In Conversation with Amar Kanwar," p. 7.

54 **"Everything is always tentative":** Ute Meta Bauer and

Anca Rujoiu, "On *The Sovereign Forest*: In Conversation with Amar Kanwar," p. 12.

54 **"are driven by an internal logic that aims to connect with audiences experientially":** Sean O'Toole, "Fault Lines," *Frieze*, Issue 122, April 2009, https://frieze.com /article/fault-lines.

55 **"If the game is fixed, how do you play?":** Amar Kanwar, in conversation with the author, July 28, 2018.

55 **"there is an intimate terrain of violence and what it does to you":** Amar Kanwar, in conversation with the author, July 27, 2018.

56 **"Can extraordinary art be made from such raw, unresolved, living material?":** Holland Cotter, "Art in Review: Amar Kanwar, 'A Season Outside,'" *New York Times*, February 20, 2004, p. 34.

CHAPTER FOUR

58 **"Please, no talking as you go through the exhibition":** Cuauhtémoc Medina in conversation with the author, June 4, 2009.

59 **"a vivid array of national self-images":** Lawrence Alloway, *The Venice Biennale 1895–1968: From Salon to Goldfish Bowl*

(London: Faber and Faber, 1969), pp. 13–25.

60 **that Mexico had won the war and achieved lasting peace:** Quoted in Cuauhtémoc Medina, "Seeing Red," in *Art in the Global Present*, edited by Nikos Papastergiadis and Victoria Lynn (Sydney: UTSePress, 2014), p. 149.

60 **"a visceral reaction to the expectation of the Mexican elites":** Cuauhtémoc Medina, "Materialist Spectrality," in *Teresa Margolles: What Else Could We Talk About?* edited by Cuauhtémoc Medina, translated by Michael Parker and Lorna Scott Fox (Barcelona and Mexico City: Verlag and Editorial RM, 2009), p. 29.

61 **"We wanted to drink beer, play music, read medical stories":** Teresa Margolles in conversation with the author, August 20, 2018.

62 **"very messy and gothic and extreme":** Cuauhtémoc Medina in conversation with the author, March 27, 2019.

63 **"gay lovers who had taken their lives in a double suicide":** Rubén Gallo, *New Tendencies in Mexican Art: The 1990s* (New Y ork: Palgrave Macmillan, 2004), p. 122.

142

63 **"profoundly evocative and silent"**: Santiago Sierra, "A Short Appendix," in *Teresa Margolles: Muerte sin fin*, edited by Udo Kittelmann and Klaus Görner (Ostfildern-Ruit: Hatje Cantz Verlag, 2004), p. 214.

64 **"an overprotected world heritage site"**: Taiyana Pimentel, "Conversation Between Taiyana Pimentel, Teresa Margolles and Cuauhtémoc Medina," p. 94.

66 **mopped with the blood of crime scenes:** Teresa Margolles in conversation with the author, August 20, 2018.

68 **not a single representative of the Mexican government attended the exhibition:** Cuauhtémoc Medina, "Seeing Red," in *Art in the Global Present*, edited by Nikos Papastergiadis and Victoria Lynn (Sydney: UTSePress, 2014), p. 153.

CHAPTER FIVE

70 **"We had too much freedom"**: Teresa Margolles in conversation with the author, August 20, 2018.

70–71 **"the kids of the doctor, the narco, and the teacher all play together"**: Teresa Margolles in conversation with the author, August 20, 2018.

73 **"You go to a party"**: Mario Garcia Torres, "Normal Exceptions," in conversation with Sofía Hernández Chong Cuy, *Artforum*, July 27, 2021.

73 **"a derisive Aztec term used to address the Spaniards"**: Á. R. Vázquez-Concepcíon, "From Thanatophilia to Necropolitics: On the Work of SEMEFO and Teresa Margolles, 1990–Now," MA thesis, curatorial practice (San Francisco: California College of the Arts, 2015), p. 3.

74 **but rather by who claims the authority to kill them:** Achille Mbembe, *Necropolitics*, translated by Steven Corcoran (Durham and London: Duke University Press, 2019), p. 92.

75 **"was one of the most turbulent periods in recent Mexican history"**: Rubén Gallo, *New Tendencies in Mexican Art: The 1990s* (New York: Palgrave Macmillan, 2004), p. 1.

76 **"you could see it in the bodies in the medical school"**: Teresa Margolles in conversation with the author, August 20, 2018.

77 **"I told him what he had done to me"**: Teresa Margolles, "Santiago Sierra," *Bomb*, Number 86, Winter 2003–2004, p. 66.

78 **"I was mad at the dealer"**: Teresa Margolles, "Santiago Sierra," p. 66.

78 **"Margolles came up with a daunting proposal":** Cuauhtémoc Medina, "Zones of Tolerance: Teresa Margolles, SEMEFO and Beyond," *Parachute*, 104, October–November 2001, p. 34.

79 **"I work with emotion, not reason":** Teresa Margolles, "Santiago Sierra," p. 64.

80 **"I think until the medium comes":** Teresa Margolles in conversation with the author, August 20, 2018.

CHAPTER SIX

82 **NAFTA:** Rubén Gallo, *New Tendencies in Mexican Art: The 1990s* (New York: Palgrave Macmillan, 2004), and Alma Guillermoprieto, "The Murderers of Mexico," *New York Review of Books*, October 28, 2010.

84 *2666:* Roberto Bolaño, 2666, translated by Natasha Wimmer (New York: Farrar, Straus and Giroux, 2008), p. 633.

88 **"I find this very touching":** Teresa Margolles in conversation with Mariella, "To Those Who Are Still Alive," in *El la herida*, edited by Florian Steininger (Munich: Hirmer Verlag, 2020), p. 91.

89 **"who fight to resemble the idea that they dream of themselves":** Teresa Margolles, *Ya Basta Hijos de Puta*, edited by Diego

Sileo (Milan: Silvana Editoriale, 2018), p. 5.

CHAPTER SEVEN

91 **"I was so fascinated by its colors and its smell":** Quoted in Paola Piacenza, "Maya Khoury: Il mio film sulla rivoluzione al festival di Locarno," *IO Donna (Corriere della Sera)*, July 20, 2019, https://www.iodonna.it/personaggi/star-internazionali/2019/07/20/maya-khoury-il-mio-film-sulla-rivoluzione-al-festival-di-locarno/.

93 **both flags are in use, depending on where you look:** Amal Hanano, "This Flag Is My Flag," *Jadaliyya*, July 11, 2011, https://www.jadaliyya.com/Details/24181.

96 **"He framed this as a continuation of his father's trajectory":** Robin Yassin-Kassab and Leila Shami, *Burning Country: Syria in Revolution and War*, p. 17.

97 **widely credited as the godfather of the revolution to come:** Yassin al-Haj Saleh, *The Impossible Revolution: Making Sense of the Syrian Tragedy*, translated by Ibtihal Mahmood (Chicago: Haymarket Books, 2017), p. 110.

98 **"arts organizations and initiatives that politically profited the regime":** Shayna

144 Silverstein, "Cultural Liberalization or Marginalization? The Cultural Politics of Syrian Folk Dance During Social Market Reform" in *Syria from Reform to Revolt, Volume 2: Culture, Society, and Religion*, edited by Christa Salamandra and Leif Stenberg (Syracuse, NY: Syracuse University Press, 2015), p. 79.

99 **"so long as the veil of abstraction or allegory remained firmly in place"**: Miriam Cooke, *Dissident Syria: Making Oppositional Arts Official* (Durham & London: Duke University Press, 2007), p. 55.

100 **"to conform with what the honest citizen was supposed to know"**: Cyril Béghin and Dork Zabunyan, "Fragments of a Revolution: An Interview with Abounaddara," in Dork Zabunyan, *The Insistence of Struggle*, translated by Stefan Tarnowski (Barcelona: If Publications, 2019), p. 120.

100 **"who invited me to reduce my project to a sort of exotic reportage"**: Quoted in Paola Piacenza, "Maya Khoury."

101 **"It was a game at the time"**: Quoted in Paola Piacenza, "Maya Khoury."

CHAPTER EIGHT

109 **"We wanted to create films like bullets"**: Sonja Mejcher

Atassi, "Abounaddara's Take on Images in the Syrian Revolution: A Conversation Between Charif Kiwan and Akram Zaatari, Part One," *Jadaliyya*, July 8, 2014, https://www.jadaliyya.com/Details/30924.

109 **"Of course, we are in a state of emergency"**: Moustafa Bayoumi, "The Civil War in Syria Is Invisible," *The Nation*, June 29, 2015, https://www.thenation.com/article/archive/the-civil-war-in-syria-is-invisible-but-this-anonymous-film-collective-is-changing-that/.

110 **"As filmmakers, our primary concern is image"**: Moustafa Bayoumi, "The Civil War in Syria Is Invisible."

110 **"The idea is always to collapse things"**: Sonja Mejcher Atassi, "Abounaddara's Take on Images in the Syrian Revolution: A Conversation Between Charif Kiwan and Akram Zaatari, Part One."

113 **who famously invented Damascene mother-of-pearl inlay**: Anneka Lenssen, "The Filmmaker as Artisan: An Interview with the Members of Abounaddara," *Third Text*, Volume 34, Number 1, p. 166.

113 **"was practically born in the workshop of this Damascene artisan"**: Anneka Lenssen, "The Filmmaker as Artisan: An

Interview with the Members of Abounaddara," p. 165.

114 **was phenomenally successful in Cairo:** Anna Della Subin and Hussein Omar, "The Egyptian Satirist Who Inspired a Revolution," *New Yorker* (online), June 6, 2016, https://www .newyorker.com/books/page -turner/the-egyptian-satirist -who-inspired-a-revolution.

115 **"We are all pacifists in Abounaddara":** Moustapha Bayoumi, "The Civil War in Syria Is Invisible."

115 **"We stuck to trying to make films by the book, but it didn't work":** Cyril Béghin and Dork Zabunyan, "Fragments of a Revolution: An Interview with Abounaddara," p. 121.

117 **"It was a digital flood":** Lawrence Wright, "Disillusioned," in *Insights into Syrian Cinema: Essays and Conversations with Contemporary Filmmakers*, ed. by Rasha Salti (New York: Rattapallax Press, 2006), p. 60.

118 **"They transit between Europe and Syria":** Rasha Salti, "Critical Nationals: The Paradoxes of Syrian Cinema," in *Insights into Syrian Cinema: Essays and Conversations with Contemporary Filmmakers*, ed. by Rasha Salti (New York: Rattapallax Press, 2006), p. 44.

121 **"We refuse to reduce our people to victims":** Charif Kiwan, "Abounaddara: The Right to the Image," organized by the Vera List Center for Art and Politics, The New School, New York, October 23, 2015, https:// veralistcenter.org/events /abounaddara-the-right-to-the -image/.

CHAPTER NINE

125 **"Forget your children. Go sleep with your wives and make new ones":** Robin Yassin-Kassab and Leila Shami, *Burning Country: Syria in Revolution and War*, p. 38.

128 **"Syria was said to illustrate the folly of imagining":** Anand Gopal, "Syria's Last Bastion of Freedom," *New Yorker*, December 3, 2018, https://www.newyorker.com /magazine/2018/12/10/syrias-last -bastion-of-freedom.

128 **"At a certain point absurdity became a strategy":** Ruba Katrib, "Abounaddara: The Right to the Image," Vera List Center.

128 **"Within hours, the army drained the fountains dry":** Rasha Salti, "Shall We Dance?" *Cinema Journal*, Fall 2012, p. 170.

129 **"insurgents dance the *dabkeh*":** Rasha Salti, "Shall We Dance?" p. 170.

146 CONCLUSION

131 **"The result is a scattered narrative":** Sadia Khatri, "A Fragmented Reality: How a Vital New Documentary Rejects Clear Readings of the Syrian Revolution," *IndieWire*, September 14, 2021.

131 **"We hate the idea":** Charif Kiwan, Post-screening Q&A, Doc Fortnight, Museum of Modern Art, February 12, 2020.

Columbia Global Reports is a publishing imprint from Columbia University that commissions authors to produce works of original thinking and on-site reporting from all over the world, on a wide range of topics. Our books are short—novella-length, and readable in a few hours—but ambitious. They offer new ways of looking at and understanding the major issues of our time. Most readers are curious and busy. Our books are for them.

Subscribe to our newsletter, and learn more about Columbia Global Reports at globalreports.columbia.edu.